T0061941

# DIRECTOR'S CHOICE
# THE ROYAL CASTLE IN WARSAW

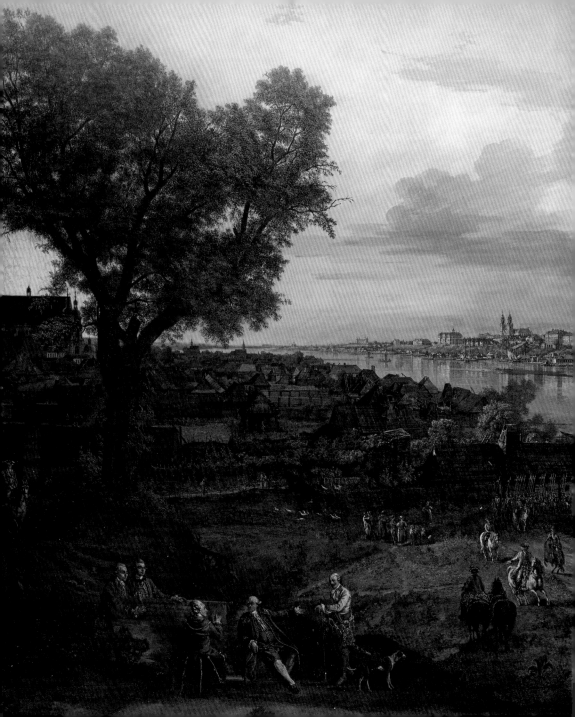

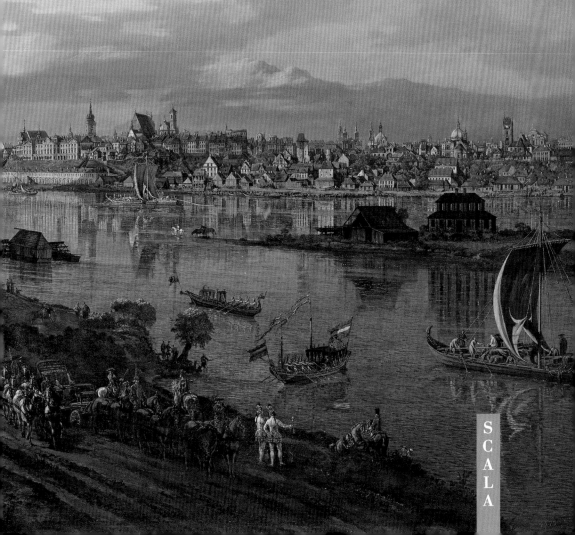

# THE ROYAL CASTLE IN WARSAW

Wojciech Fałkowski

SCALA

# INTRODUCTION

Perched on a high bluff above the Vistula River, the Royal Castle has occupied its present location for 400 years. Construction began at the end of the sixteenth century by order of King Zygmunt (Sigismund) III of the Vasa dynasty, and was not completed until 1619. The new building immediately became the main administrative centre of a vast state stretching from the Baltic Sea to the Carpathians, and from Smolensk in the east to the borders of the Holy Roman Empire. Now elevated to the principal residence of Poland's monarchs, a role previously performed by Kraków's Wawel, the Castle became the focal point for the country's political elite and attracted outstanding artists, sculptors and architects from all over Europe. Successive rulers enriched the collection of paintings, staged opera and theatre performances, and surrounded themselves with poets, playwrights and musicians. The Warsaw court became a vibrant centre of the arts, competing with other European courts. Culture during the Baroque period was financed by wealthy patrons who combined a love of art with grand political and military plans. In the seventeenth century, despite destruction and plunder, the Castle managed to retain its importance and avoid decline, but the following century was not so kind to the city or the country. It was not until the second half of the eighteenth century that the Castle was transformed into a splendid residence inhabited by politicians and artists. The rich decoration of the chambers, the carefully assembled collection of artworks, and the regular meetings of writers and scholars once again turned the Castle into the country's foremost artistic and intellectual hub. Today, the magnificent historic interiors are among the finest examples of Enlightenment art. Towards the end of the eighteenth century, the last king of Poland, Stanisław August, transformed the Castle into a residence that would become the envy of his allies and rivals alike.

The Castle currently performs three functions that harmoniously complement each other to create a unique atmosphere. First and foremost, the former royal residence is now a beautiful museum of interiors which recreates the Enlightenment era and displays the art and craftsmanship of that period, while the gallery of painting located in the Castle's second wing houses masterpieces of European art from the late Renaissance and Baroque periods. Together these form a diverse historical museum boasting a magnificent collection of artefacts dating from the end of the Middle Ages until the Partitions of Poland in the late eighteenth century. Works created during the 'Republic of Nobles' (1569–1795) in the then fashionable Sarmatian style (a fusion

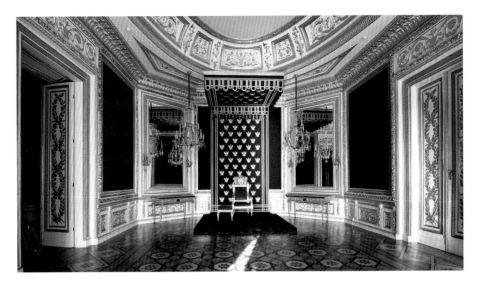

of Catholic high Baroque with Oriental culture) are juxtaposed with fine examples of painting and decorative art originating from the bourgeois and court cultures of Western Europe. The Castle is also a meeting place for politicians, artists and scholars from all over the world, who contribute with lively debates, bold ideas and creative proposals that brilliantly link the past with present-day life and plans for the future. In this way, history changes before our eyes: from a dry textbook narrative into a passionate story of ideas, emotions and events.

Finally, there is the third function, which our visitors find particularly moving and which inspires reflection: the Castle as a symbol of the unbreakable will of the Polish nation, which refused to surrender despite 120 years of captivity and the devastation of the Second World War. The Castle was completely destroyed by the Nazis, and after the war, against the wishes of the Communist regime, it was rebuilt thanks to huge support from the Polish public. It rose like a phoenix from the ashes – in accordance with the nation's wishes and in defiance of the resistance and reluctance shown by the authorities. Now, as in centuries past, the Castle rises majestically above the Vistula valley, its massive silhouette visible from afar. Found within its walls is a remarkable collection of outstanding works of art, which lend a unique atmosphere to the historic interior.

<div align="right">

PROF. WOJCIECH FAŁKOWSKI
*Director of the Royal Castle in Warsaw – Museum*
*Residence of Polish Kings and of the Commonwealth*

</div>

Rembrandt van Rijn (1606–1669)

## *Girl in a Picture Frame*, 1641

Oil on poplar panel, 105.5 × 76.3 cm
From the former collection of Stanisław August
Donated by Karolina Lanckorońska in 1994
ZKW/3906

Rembrandt Harmenszoon van Rijn was one of the most distinguished artists working in the seventeenth-century Netherlands. He was born in Leiden, where he apprenticed as a painter and ran his first studio. In the early 1630s he moved to Amsterdam, where he began working with the painter and art dealer Hendrick van Uylenburgh. Rembrandt's career developed very rapidly. By the early 1640s he was already one of the most famous portrait painters in Amsterdam, receiving commissions from important figures.

It was during this period that Rembrandt painted *Girl in a Picture Frame*. Although traditionally referred to as a portrait, it is actually a *tronie* – the name given to a type of work common in Dutch painting in which unidentified persons are depicted with exaggerated facial expressions or in costume. The girl's dark red velvet dress decorated with gold chains, and her black hat, are not associated with the fashion of the time. They represent outdated clothing that often featured as costume in seventeenth-century paintings on mythological or biblical themes. *The Girl in the Picture Frame* is an example of *trompe l'oeil* technique, by which Rembrandt attempted to create the best possible illusion of reality. To that end he applied various methods, such as 'piercing the surface' of the painting, by which painted elements seem to enter the viewer's space. For instance here, he introduced an illusory frame to mark the boundary between the painted world and the real world. The portrayed girl crosses that boundary by placing her hands on the frame, thus entering, as it were, our space. In addition, the figure is captured as if in motion. The girl has already grasped the frame with one hand, and is about to grasp it with the other, while the pearl earring hanging from her right ear, which is tilted slightly off the vertical, suggests that she is moving towards the frame.

Both works by Rembrandt in the Royal Castle collection are undoubtedly among the most outstanding works on display in any Polish museum. There is one more painting by the Dutch master which can be seen in Poland. Dating from 1638, *Landscape with a Good Samaritan* is housed in the National Museum in Kraków, and like the two Warsaw works, it came to Poland in the second half of the eighteenth century.

**MK**

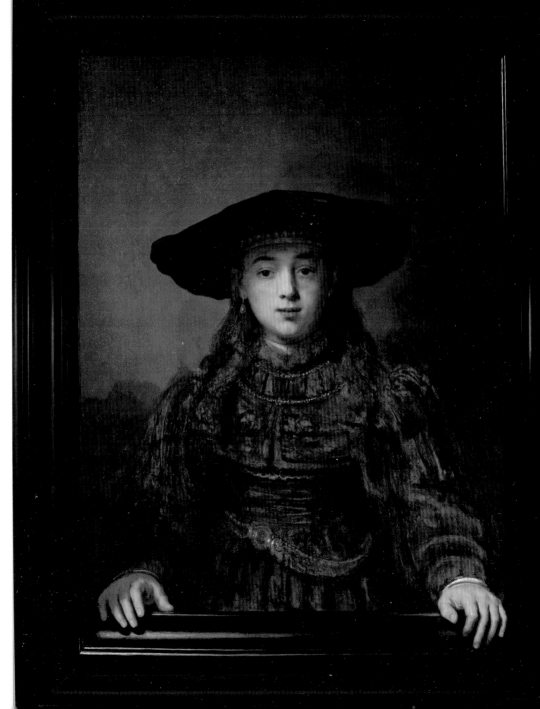

Rembrandt van Rijn (1606–1669)

## *Scholar at his Writing Table*, 1641

Oil on poplar panel, 105.7 × 76.4 cm

From the former collection of Stanisław August

Donated by Karolina Lanckorońska in 1994

ZKW/3905

Scholar at his Writing Table and *Girl in a Picture Frame* from the Royal Castle collection were painted by Rembrandt in 1641. His signature and the date appear directly on the front of both works (in this case on the side of the writing table). The works are painted on poplar panels, which Rembrandt used quite rarely, and both have identical dimensions. However, despite their many common features, which suggest that the works were meant to be pendants, or companion pieces, this was not the artist's original intention. They do not observe the rule that Rembrandt followed when making pairs of portraits, which was to place the male portrait on the left, and the female on the right. Furthermore, in terms of composition, the works do not share the same scheme: the scale of the figures and their settings are different. Even their identical dimensions are a consequence of later trimming. Nevertheless, in the earliest mentions we know of, the paintings were considered a pair. Their first owner was probably the Amsterdam merchant Jan van Lennep the Elder. In the second half of the eighteenth century, the paintings found their way to the collection of Count Friedrich Paul von Kamecke in Berlin, who presented them as *The Jewish Bride* and *Bride's Father Writing Down Her Dowry*. The works were bought by King Stanisław August in 1777, and later, through inheritance and purchases, they became the property of the aristocratic Rzewuski and then Lanckoroński families. In 1994, the last member of the clan, Prof. Karolina Lanckorońska, donated both paintings to the Royal Castle in Warsaw.

Scholar at his Writing Table is an example of a recurring image in Rembrandt's paintings and prints – that of the old scholar or philosopher. It belongs to the category of representations referred to as *tronies*, which are studies of physiognomy – heads or half figures dressed in oriental garb, high turbans, gold chains or other costume. The scholar's clothing in the painting shown here is not typical of the period; it is an example of archaic attire inspired by the fifteenth century – in this case a tabard. Rembrandt brilliantly captures the moment when the thinker breaks away from his work for a moment to engage in deeper reflection, as evidenced by his gaze and his absent expression.

**MK**

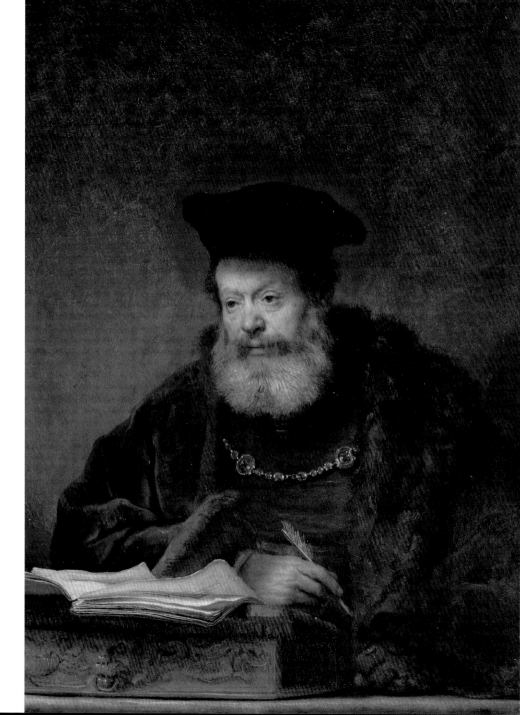

Attavante degli Attavanti and his circle, painter
Sigismundus de Sigismundis, scribe

### *An illuminated Book of Hours, also known as Queen Bona's Prayer Book,* Horae ad usum Ecclesiae Romanae

Manuscript: Florence, 1492;
Binding: Warsaw, 1840s–50s
Manuscript: vellum, parchment, tempera, gold paint
Binding: silver, enamel, velvet, grosgrain
Page: 14.7 × 9.7 cm, binding: 17.5 × 13 × 6.5 cm
From the former collection of Jan II Kazimierz
ZKW/1512

This prayer book belonged to Queen Bona Sforza and was probably commissioned for her, as indicated by the painted coats of arms of Poland, Lithuania and the Sforza family, the latter depicting a serpent, which were probably added in the sixteenth century. The manuscript has 259 pages, of which the 246 containing text are vellum pages. The remaining 12 were made of thicker parchment and are covered with painted decoration. The text of the Latin prayers was written down by the scribe Sigismundus de Sigismundis of Ferrara in 1492. At the end of the texts for each month are short sentences in Italian, including: *a di 24 in comincia del Jubileo i sca maria del fiore*, which indicates Florence as the place where the manuscript originated. The prayer book contains 11 full-page miniatures from the Florentine workshop of Attavante degli Attavanti. These depict, in sequence: *The Annunciation, Mary and Child, David Triumphant over Goliath, David Playing the Harp, The Three Living and The Three Dead, Death, The Crucifixion, Prayer in the Garden of Gethsemane, Christ Carrying the Cross* and *The Descent of the Holy Spirit*. The illuminations were done in tempera, with carmine, blue, green and gold being the dominant colours.

The prayer book was taken to France by King Jan II Kazimierz (John II Casimir) and presented to Madame de la Vallière, before being given to the Princess of Conti. It was probably bought in 1808 in Paris by Stanisław Kostka Potocki. In the middle of the nineteenth century, the prayer book received a new silver binding decorated with medallions bearing three coats of arms: the White Eagle of Poland, the Mounted Knight of Lithuania and the Serpent of the Sforza family. The eagle motif was also repeated on the red-coloured edges of each page. In 1933, Adam Branicki, the heir to the Wilanów estate near Warsaw, donated the prayer book to the Royal Castle collection by giving it to the President of Poland, Ignacy Mościcki (at that time the Castle was his official residence). Transported out of Poland in September 1939, the book ended up in Canada; upon its return in 1959, it was placed in the National Museum in Warsaw and it has been in the Royal Castle collection since 1984.

**MZd**

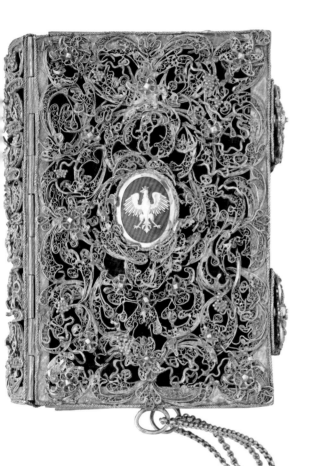

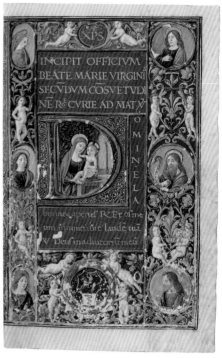

LUCAS CRANACH THE ELDER (1472–1553)

## *Adam and Eve*, 1525–30

Oil on lime panel, 18.5 × 27 cm
Acquired in 1986
ZKW/2085

LUCAS CRANACH THE ELDER was court painter to the Saxon princes in Wittenberg; from 1550 to 1551 he worked in Augsburg and Innsbruck, and from 1552 in Weimar. He mainly painted portraits and mythological and religious scenes.

A recurrent theme in Cranach's oeuvre is the biblical story of Adam and Eve, which appears in more than 20 of his works. The artist produced these paintings between 1508 and 1546 in the form of diptychs or single compositions. The primogenitors are usually depicted as full-length figures standing on either side of the Tree of Knowledge, sometimes near or against the trunk, in an embrace. The symmetrical arrangement of the figures in relation to the tree was inspired by a copperplate engraving made by Albrecht Dürer in 1504. In some versions of the story Eve hands the apple to Adam, but in most cases – and in the painting shown here – they hold the fruit together. This seems to symbolise their shared responsibility for the sin they have both committed.

Adam and Eve were originally shown as full-length figures, but the painting was subsequently cut at the bottom to three quarters of its height. It initially measured around 40 cm, which is a rather unusual size when compared with Cranach's other works. Most of the images of the First Parents painted by the artist are compositions in which the models are either small, measuring approximately 50 by 35 cm, or nearly life-size. Despite the difference in sizes, Cranach did not vary his approach to the subject.

The high quality of the painting, the very fine brushwork of the hair, the delicate modelling of the faces and the underdrawing characteristic of Cranach's technique – which was executed with a goose quill directly onto the canvas and which can be occasionally seen on the figures through the fine glazes – confirm that the work is an original. However,

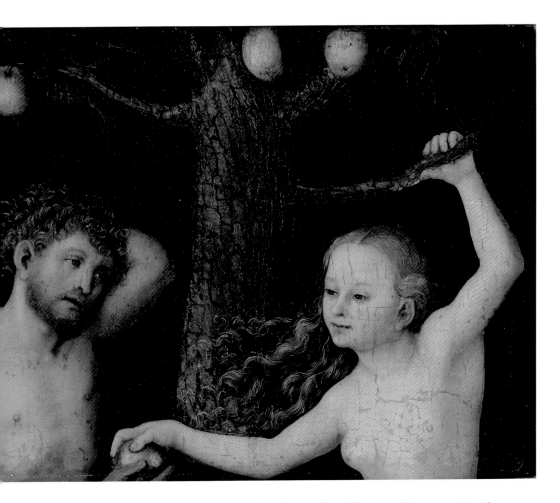

the trunk of the tree is of somewhat inferior quality, suggesting the involvement of Cranach's collaborators in this part of the painting.

The composition and arrangement of the figures, their physiognomic types and several other aspects characteristic of Cranach's paintings from the same period, suggest that the work was probably created in the second half of the 1520s.

**MK**

UNIDENTIFIED ROMAN SCULPTOR AFTER PRAXITELES

## *Satyr at Rest*, 2nd quarter of AD 200

White marble, 179 cm
From the former collection of Michał Ludwik Pac
ZKW/1899

THIS SCULPTURE DEPICTING A SATYR at rest is a replica of the famous statue by Praxiteles (*c.* 200–300 BC). Among the copies closest in appearance to the sculpture in the Royal Castle are the figures in the Hermitage in St Petersburg, the Prado in Madrid and the Lateran Museum in Rome. The Warsaw sculpture is distinguished by the wreath around the youth's head.

Prof. Kazimierz Michałowski, the renowned Polish archaeologist and expert on antiquity, identified the white marble used in the work as being from Mount Pentelicus.

The sculpture has an interesting history. As late as the beginning of the twentieth century, it still adorned the Winter Palace in St Petersburg. Under the Treaty of Riga it was given to Poland as compensation for the antique collections of Michał Ludwik Pac, plundered by the Russians in 1851 and never found since. From 1928 to 1939 it was exhibited at the Royal Castle, at that time the residence of the President of Poland. After the outbreak of the Second World War it was hidden in the National Museum in Warsaw, returning to the Castle in 1988.

**AB**

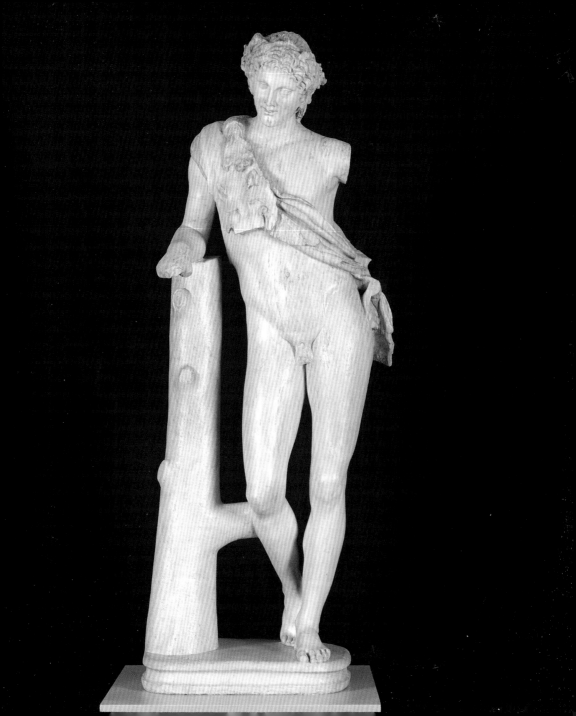

CORNEILLE DE LYON (?–1575)

## *Antoine de Bourbon*, 1548

Oil on walnut panel, 16.4 × 13.7 cm

From the former collection of Stanisław August

Donated by Karolina Lanckorońska in 1994

ZKW/3912

ANTOINE DE BOURBON (1518–1562) was the king of Navarre (1555–1562) and father of Henry IV of France (1553–1610). In this bust-length portrait he is shown facing slightly to the left and looking into the distance, beyond the frame of the painting. He is dressed in a doublet (a close-fitting padded jacket) with a high stand-up collar supporting a ruff (a projecting frill around the neck). On his head he wears a flat cap with a white feather and he has a long chain hanging from his chest. The background of the portrait is a neutral blue-green colour.

The portrait belongs to a small group of sixteenth-century works in the Royal Castle collection and is one of relatively few paintings by this outstanding artist that have survived to the present day.

Corneille de Lyon was originally from The Hague but lived most of his life in Lyon, hence his nickname. The artist painted this likeness of Antoine de Bourbon according to the compositional scheme he used in all his other portraits. Nevertheless, the image exudes extraordinary realism, as do other works by Corneille de Lyon, each of which is a unique, highly individual study of the person depicted. This is partly due to the approach taken by the artist, who would paint portraits *ad vivum* – that is, by looking directly at the person posing – and would rarely rely on preparatory drawings. The portrait of Antoine de Bourbon was probably painted in 1548, when he arrived in Lyon before his marriage to Jeanne d'Albert, the daughter of King Henry II of Navarre and the niece of Francis I, king of France.

**AJ**

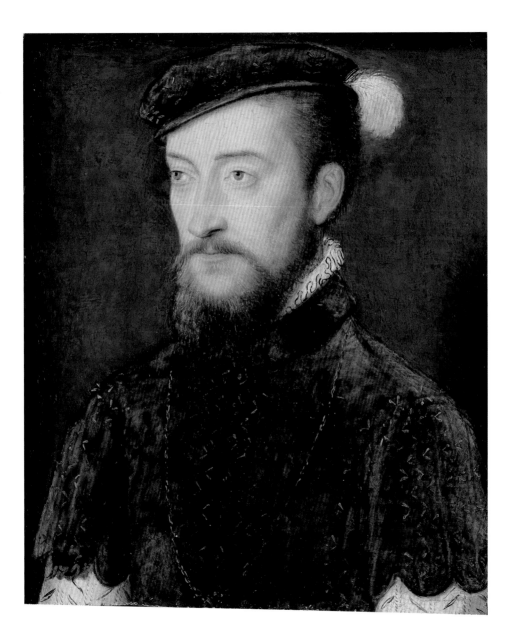

MICHIEL COXCIE (1499–1592), author of the cartoon
CORNELIS FLORIS (1514–1575), design of the border by an artist from his circle

## *Moral Downfall of Humanity Before the Flood,* c. 1550
Brussels

Wool, silk, silver and silver-gilt threads, 452 × 612 cm
Donated by the Soviet Union
ZKW/511

MORAL DOWNFALL OF HUMANITY BEFORE THE FLOOD is one of the Wawel
tapestries commissioned by King Zygmunt II August (Sigismund II
Augustus). The collection of magnificent fabrics woven in Brussels has
survived almost intact and is stored at Wawel Castle in Kraków.

The tapestry depicts a scene of violence and rape that was the
cause of the Flood. This can be deduced from the inscription in the
upper border, which refers to the Book of Genesis (6:1–7), where the
unworthy deeds of Cain's descendants are described. The author
of the cartoons, a prominent Flemish painter, illustrated it with a
dynamic scene, the dominant figure being a rider on a rearing horse
which is trampling over those who have been knocked to the ground;
on the left is a scene of rape, and in the background prisoners are
shown crossing a bridge. The artist, who specialised in producing
cartoons for tapestries, was influenced by Italian art and was known
by his contemporaries as 'the Flemish Raphael'. For this design he
drew inspiration from, among others, the Vatican frescoes of Giulio
Romano (*The Battle of Milvian Bridge,* 1534, located in the Sala di
Costantino) and Raphael (*The Meeting of Leo the Great with Attila,*
1513–14, in the Stanza di Eliodoro).

The tapestry was hung in the Royal Chambers at Wawel Castle
to mark the wedding of Zygmunt II August to Catherine of Austria
in 1553. In 1795, together with other tapestries, it was transported
from Warsaw to St Petersburg. However, it did not return to Poland
when Russia surrendered many artworks and other Polish national
treasures under the terms of the Treaty of Riga in 1921. An art
historian from Kraków recognised it during a temporary exhibition
held at the Pushkin Museum in Moscow in 1972, after which the
tapestry was donated as a 'gift' from the Soviet Union to the newly
rebuilt Royal Castle in Warsaw.

KP

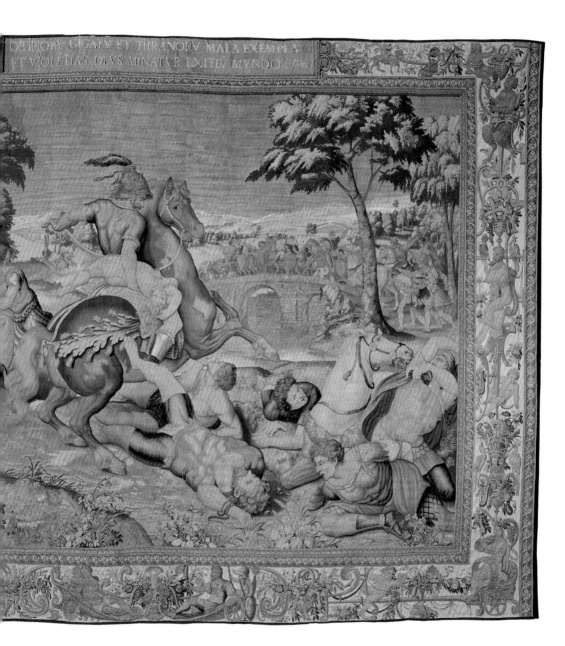

UNKNOWN WORKSHOP

## *Stockholm Scroll*, after 1605

Watercolour, gouache, tempera, ink, gold paint on laid paper
28 × 1528 cm (39 parts in total)
Donated by the Swedish government in 1974
ZKW/1528/1-39

MEASURING 15 METRES IN LENGTH, the *Stockholm Scroll* depicts, in the form of a miniature frieze, the ceremonial entry into Kraków of the wedding cortège of King Zygmunt (Sigismund) III and the Archduchess Constance of Austria on 4 December 1605. The work was donated to the Royal Castle in Warsaw in 1974 by the Prime Minister of Sweden, Olof Palme. It was previously in a museum collection in Stockholm, where it probably ended up as war booty after the Swedish Deluge – the invasion of Poland by the armies of Charles Gustav in the mid-seventeenth century.

The drawing, by an artist from an unidentified workshop, is executed on paper in watercolour, gouache and gold paint; it shows nearly 600 participants of the procession. The main protagonists are King Zygmunt III riding a chestnut horse, and his wife Constance riding in a black and gold carriage. Among the figures depicted on the Scroll are Władysław (Ladislaus), the then ten-year-old Polish prince and heir to the throne, the mother and sister of the Archduchess Constance, the Archduke Maximilian Ernst of Austria, the Papal Nuncio Claudius Rangoni, the Grand Standard Bearer of the Polish Crown Sebastian Sobieski, and the Palatine of Poznań Hieronim Gostomski. Particularly intriguing is the figure of the so-called 'Bearded Woman', or Helena Antonia of Liège, a lady-in-waiting for the Habsburgs. Also noteworthy is the magnificent presentation of the hussars (light cavalry) – a symbol of the forces of the Polish Crown at that time.

The great value of the *Stockholm Scroll* lies in the way that it precisely and realistically recreates the details of clothing and weaponry and attempts to individually portray important historical figures. The work reflects the splendour of both the court and the wedding ceremony itself.

**MZd**

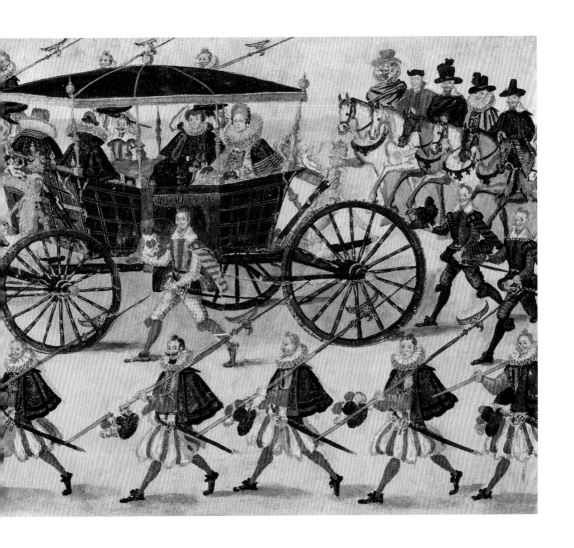

GIOVANNI BATTISTA CARACCIOLO, CALLED BATTISTELLO (1578-1635)

## *St John the Baptist* (?), *c.* 1610

Oil on canvas, 63 × 49.5 cm
Acquired in 2020
ZKW/5880

BATTISTELLO WAS AN ITALIAN Baroque painter and one of the most prominent followers of Caravaggio (1571–1610). The work shown here most likely depicts St John the Baptist. Because the saint's traditional attributes, such as a lamb, a camel-skin robe and a scroll inscribed with the words Ecce Agnus Dei are missing from this painting, it is difficult at first glance to see it as a religious representation. The young man's mysterious smile, and his pose – nonchalantly propped up on his elbow – likewise seem to suggest a non-religious theme. However, the painting shows similarities to another work by Caracciolo on the same subject and to works by other artists working in Caravaggio's circle. The way the saint is presented – close up, without distinctive attributes, and against a dark uniform background – allows the focus to rest on the masterful depiction of the human body and the bold use of chiaroscuro.

According to Stefano Causa, the author of a monograph on Caracciolo, the painting was executed just before 1610. This means that it would be a very early assimiltaion of Caravaggio's style. Indeed, it would suggest that Caracciolo reacted almost immediately to the works being created by Caravaggio, who was in Naples at the time.

AJ

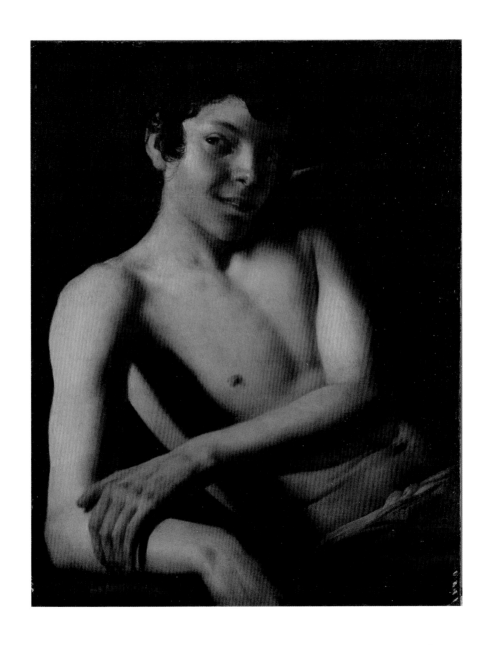

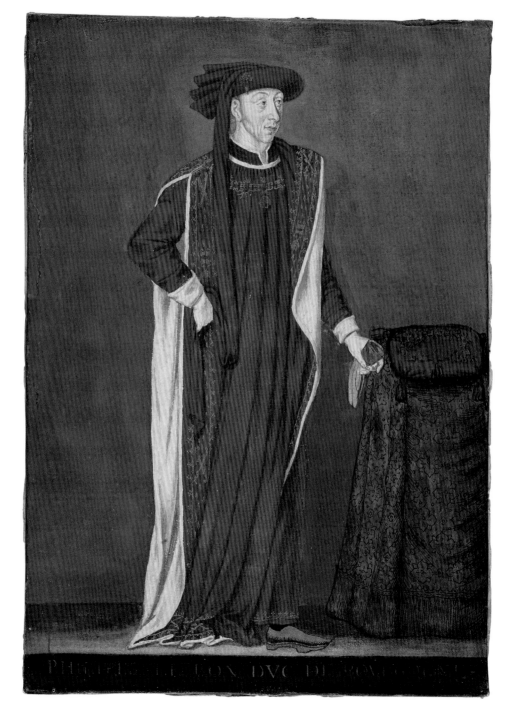

PHILIPPE LE BON DVC DE BORGOIGNE

FRENCH PAINTER

## *Philippe le Bon*, 1620s

Gouache on laid paper, 32.3 × 23 cm

Pre-1683 collection of Jean-Baptiste Colbert, from the former collection of Stanisław August

Donated by Karolina Lanckorońska in 1994

ZKW/3922/ab

PHILIPPE LE BON (Philip the Good; 1396–1467), Duke of Burgundy, was a ruler who contributed greatly to the territorial expansion and cultural development of the lands under his control. Here he is portrayed as the Grand Master of the Order of the Golden Fleece. He is dressed in a red chasuble and a head covering known as a *chaperon*, with the chain of the Order around his shoulders. The Order of the Golden Fleece was originally an order of knights established by Philippe le Bon in 1430 to defend the Christian faith and promote virtue. Membership was open only to men of the Catholic faith, of impeccable reputation and of noble descent. Over time it became a prestigious honour that is now considered historically the most important of its kind.

The first person in Poland to receive the Order of the Golden Fleece was King Zygmunt I Stary (Sigismund I the Old). Thereafter it was given to each successive ruler of Poland (with a few exceptions). In 1903, Count Karol Lanckoroński (1848–1933), Grand Chamberlain of the Austrian court, art historian and collector, became a Knight of the Order. His daughter, Professor Karolina Lanckorońska, donated this image of Philippe le Bon to the Royal Castle collection in Warsaw, together with other artworks (including a portrait of Henry III and paintings by Rembrandt).

**AJ**

FRENCH PAINTER

*Henry III*, 1620s

Gouache on laid paper, 33.3 × 23 cm

Pre-1683 collection of Jean-Baptiste Colbert, from the former collection of Stanisław August

Donated by Karolina Lanckorońska in 1994

ZKW/3921/ab

THE POLISH KING HENRYK I Walezy (Henri de Valois; 1551–1589), later King Henry III of France, was the fourth son of King Henry II of France and Catherine de' Medici. At the time of his birth, however, there was nothing to suggest that he would eventually inherit the throne of France. For this reason, among others, Catherine de' Medici made efforts to install her son on the Polish throne. In May 1573 Henry became the first Polish ruler to be elected by means of a free vote in which all members of the *szlachta*, or Polish nobility, could take part. Henry stayed in Poland only from January to June 1574, after which he fled to France to succeed his late brother Charles IX as King Henry III.

This portrait shows Henry wearing the robes of the Grand Master of the Order of the Holy Spirit: a black velvet chasuble with the embroidered star of the Order, a cape of green moiré silk, a white ruff and a black bonnet; the chain of the Order hangs from his neck. The chasuble and cape are embroidered with golden flames in reference to the name of the Order. Henry III established the Order of the Holy Spirit to reward his supporters. It was a prestigious honour, available only to a select few. The portrait belonged to the collection of Jean-Baptiste Colbert, the finance minister of Louis XIV and treasurer of the Order of the Holy Spirit.

**AJ**

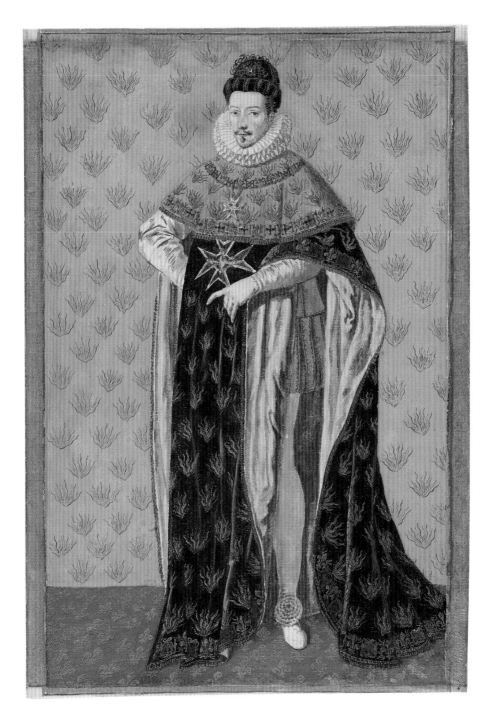

## The Cabinet of Curiosities of Prince Władysław Zygmunt Waza, 1626

Oil on oak panel, 72.5 × 104 cm

Acquired in London through Andrzej Ciechanowiecki in 1988

ZKW/2123/ab

This work depicts items from the art collection of Prince Władysław Zygmunt Waza (Ladislaus Sigismund Vasa), later King Władysław IV of Poland, who purchased them during his Grand Tour in 1624–25, when he visited Vienna, Germany, the Netherlands, France and Italy. It is a unique work as it illustrates a royal collection which was soon to be dispersed.

The date on the painting indicates that it was made one year after Władysław returned from his travels. In the middle of the composition, on the engraving, the work is signed as follows: *Here. (?) fecit / Warsau (?) 1626*. Although the signature is legible, how the painting came into being and the identity of the painter remain unknown. The stylistic features of the work suggest an artist of Flemish origin, probably active in Antwerp.

The painting depicts the prince's art collection, among which the following works can be identified: *Drunken Silenus*, attributed to Peter Paul Rubens or Anthony van Dyck; partially visible behind it a fragment of *The Virgin and Child Encircled by a Garland* by Jan Breughel the Elder and Hendrick van Balen; in the upper left corner one of a pair of paintings by David Vinckboons entitled *Peasant's Joy (The Expulsion)*; and below that *Still Life with Fruit and Chalice*. On the right of the table is a bronze version of Giovanni da Bologna's famous sculpture *The Rape of the Sabine Women* (original in marble, 1583). On the left, the drawing in the open sketchbook is *Allegory of the Victory of the Arts and Wisdom over War* attributed to Hans Krieg. Visible just to the left of the vertical axis, obscured by the sketchbook, is a print that makes reference to the engraving *Tobias and the Angel* by Hendrik Goudt, dated 1608, based on a painting by Adam Elsheimer. Władysław Zygmunt is himself depicted twice in the work: on the gold medal placed prominently in the right foreground and in the miniature portrait placed behind the seascape.

**MK**

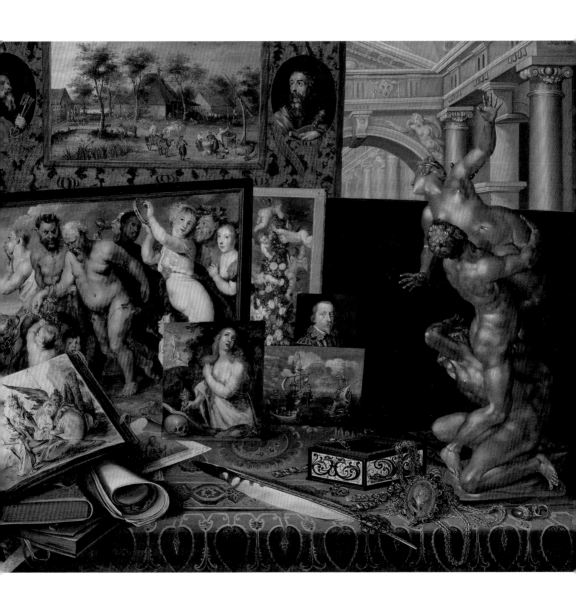

WORKSHOP OF JAN LEYNIERS II (1630–1686)

### *Tapestry with the Coat of Arms of Michał Kazimierz Pac*, 1667–69

Wool, silk, 249.5 × 186 cm

On loan from the Ciechanowiecki Foundation Collection

ZKW-dep.FC/255

THE TAPESTRY FEATURES THE COAT OF ARMS of Michał Kazimierz Pac (1624–1682), one of the most prominent Lithuanian magnates, a soldier and politician during the reign of King Jan II Kazimierz (John II Casimir), Field Hetman of Lithuania (1663–1667), Grand Hetman of Lithuania (1667–1682), Palatine of Vilnius (from 1669), Castellan of Vilnius (1667–1669) and founder of the family's huge wealth.

Placed at the centre of a five-quarter shield is the Pac coat of arms – the Gozdawa; around it are four other coats of arms: Łabędź (the Swan), Kościesza, Bogoria and Pogonia (the Mounted Knight of Lithuania). The shield is topped by three crowned helmets with plumes of peacock feathers on which the Łabędź, Bogoria and Kościesza coats of arms are repeated. The letters around the coats of arms refer to Pac himself: M. (ichał) K. (azimierz) P. (ac) / K. (asztelan) W. (ileński) / H. (etman) W. (ielki) W.(ielkiego) X. (ięstwa) L. (itewskiego) [Michał Kazimierz Pac / Castellan of Vilnius) / Grand Hetman of the Grand Duchy of Lithuania]. The border is decorated with a panoply motif: armour, shields, helmets, cold steel weapons, firearms and cannons. On the lower selvedge the fabric is signed with the name *Ian Leynis*, which refers to the Flemish tapestry weaver Jan Leyniers II, and the letters 'B B' separated by a red shield, indicating Brussels.

The tapestry comes from the Church of SS Peter and Paul in Antakalnis (Antokol), Vilnius. It was funded by Michał Kazimierz Pac and his brother Kazimierz, the Bishop of Samogitia (Żmudź), and is the burial place of Michał Kazimierz Pac. It was part of a series of tapestries, the original number of which is unknown, and was woven in one of the major Brussels workshops of the time. The tapestries belonging to the collection were decorated with identical coats of arms and inscriptions; they differed in the shades of the backgrounds and in the decoration of the borders. Three fabrics sporting borders decorated with panoplies (two in the Royal Castle in Warsaw and one in the National Museum of Lithuania in Vilnius) and two with floral borders (in the National Museums in Kraków and Poznań) have survived to the present day.

The tapestry is an example of the decorative fabrics – much sought after in the seventeenth century – that were used to furnish magnates' residences and public buildings, where they performed a representative and a propaganda function, emphasising the status of their owner. The wealthiest magnates, a group to which Michał Kazimierz Pac belonged, often commissioned them from famous Flemish workshops.

**KP**

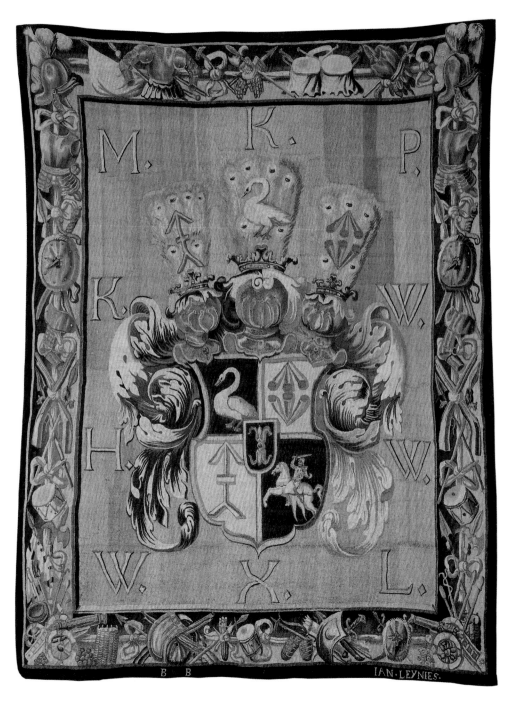

M. K. P.

K. W.

H. W.

W. X. L.

B B          IAN·LEYNIES·

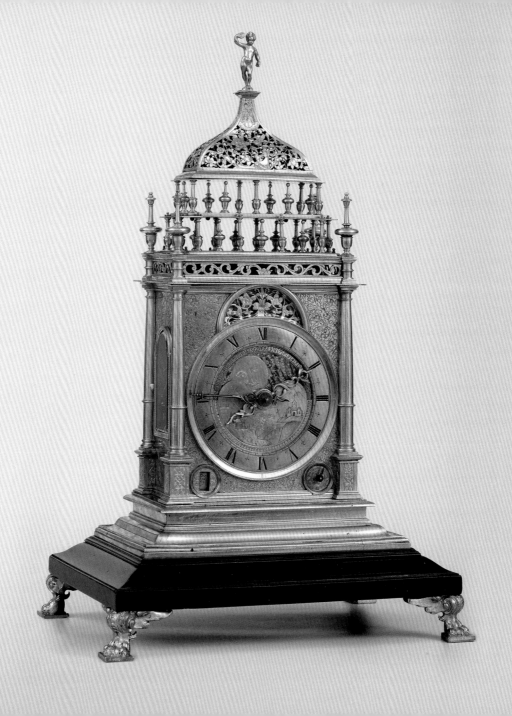

Johann Wüttkei (d. 1691)

*Tower Clock*, 1657–*c.* 1670
Wrocław
Wood, brass, 51.5 × 32.8 × 25.1 cm
On loan from the Teresa Sahakian Foundation (who acquired it in 2017)
ZKW-dep.FTS/777

This unique tower clock has two superimposed dials showing the hours, minutes and days of the month, as well as a lunar calendar and a moon phase dial, and strikes the hours and quarters in a *Grande Sonnerie* system.

The clock is of special value not only on account of its masterful construction and form, but also because during the reign of August III (Augustus III) there were at least seven pieces by Wrocław clockmakers in the King's Warsaw residences and at least four clocks in the Castle itself.

The clock is topped with an openwork canopy adorned by a figure of a putto. The front dial with an hour and quarter scale bears the signature *Johan Wüttkei / A Breslau* (the German name for Wrocław). The back dial with a minute scale has a lunar calendar window inside with a moon phase dial. Set underneath the dial is a day of the week window with symbols. The side walls are decorated with engraved scenes: on the left is a couple dressed in mid-seventeenth-century costume sitting under a tree; on the right – a sower and a ploughman with a pair of oxen and a ploughshare, with trees and birds.

The main mechanism located within the body has two main parts: a timekeeping train controlled by spindle escapement and balance wheel, and a striking-train for hours; in the base is an additional striking-train for quarters. All the parts are driven by springs located in the drums and connected by Gall chains to the snail-shaped cam.

Only three works by Johann Wüttkei (active before 1657, died in 1691) are known: a table clock in the National Gallery of Victoria in Melbourne; a pocket watch in an openwork case with a motif of birds adoring the Tree of Life in the Metropolitan Museum of Art in New York; and the clock shown here, which appeared at an auction in 1929. Until the 1990s, it was in the collection of Leopold and Antoinette Bloch-Bauer, and then of Elisabeth Sturm, in Vienna.

KN

CORNELIUS NORBERTUS GYSBRECHTS (?–after 1683)

## Trompe l'oeil *with Violin, Painting Tools and Self-Portrait*, 1675

Oil on canvas, 107.5 × 76 cm

Bequest of Tadeusz Wierzejski in 1974

ZKW/679/ab

ALTHOUGH A NATIVE OF ANTWERP, Cornelius Norbertus Gysbrechts mainly worked outside his homeland. In the 1760s he was active in the German lands and at the royal court in Copenhagen in the service of Frederick III and Christian V; in the early 1770s he was in Stockholm. Gysbrechts specialised in still lifes and especially *trompe l'oeil* paintings – illusionistic works which show a two-dimensional surface in such a way as to give the impression of a three-dimensional space that is in the same reality as the viewer.

The work shown here is an example of *trompe l'oeil* and shows a fragment of the artist's studio. A palette and brushes are affixed to a wall made of pine boards, while placed to the left is an oval miniature containing a self-portrait of Gysbrechts. Stuffed behind a red belt are painting accessories and letters, including one addressed to the artist, as well as sheet music and illustrations, the *Oprechte Haerlemse* newspaper, a pen, a comb and a blue velvet cloth. A violin and a bow, suspended from the wall by means of a green ribbon, complete the collection of items. Between 1663 and 1675 the artist executed five still lifes similar to this one.

The painting attests to the artist's skill in depicting illusion and various types of materials, and also contains a deeper symbolism. The violin and sheet music are symbols of the sensual aspect of human life (*vita voluptaria*) associated with entertainment and pleasure; the writing materials, newspaper and letters symbolise practical life (*vita practica*); while the painting tools represent creative or spiritual life (*vita contemplativa*).

The work is signed three times: *Monsieur / Cornelius Gisbrechts / presentement [sic] en / Breslau* (on the letter near the stick of sealing wax); *C.N. Gysbrech [...]* (below the illustration of trees); *C.N. Gysbrechts A. 1675* (below the etching needle). The date and place where the painting was created (Breslau 1675), which are included in the signatures, give us more information about Gysbrechts' biography. They allow us to determine when the artist's stay in Sweden ended and the route of his return journey to the German lands – via Breslau (today's Wrocław). The Warsaw painting is chronologically one of the last clues about the painter's activity, as his fortunes after 1675, including the date of his death, are unknown.

**MK**

### *Cabinet for Duke August Wilhelm's Collection*, c. 1730
Brunswick

Walnut, pine, gilt brass, 246 × 139 × 54 cm

Donated by the Ministry of Art and Culture in 1989

ZKW/3164

THE LATIN PHRASE *PARTA TUERI* – (defend what you have won) is a symbolic motto adorning the door of this cabinet; it refers to the valuable contents, but above all it is the heraldic motto of the cabinet's first owner, August Wilhelm, Duke of Brunswick-Wolfenbüttel, who was from one of the oldest German-Italian families – the Welfs. During his reign (1714–31), the Duke amassed a substantial collection of decorative art, which he decided to display in one of his residences, the Grey Castle (Graue Schloss) in Brunswick. Special cabinets, commissioned from local workshops, were to provide a worthy setting for the collection. The set of cabinets, to which the piece shown here belongs and which is artistically the most interesting, consisted of nine items and was completed *c.* 1730. The furniture was of similar shape and size, veneered in walnut with discreet ribbon inlay. What made the individual pieces different and unique were the openwork grilles, cut in brass, engraved and gilded.

As regards the cabinet from the Royal Castle collection, the main element of the decoration, apart from the Welf coat of arms, is the resting lion – an element of the coats of arms of Brunswick and Lüneburg, which were cities and principalities belonging to this family. The arabesque ornament of the grille was undoubtedly inspired by the graphic works of the famous French draughtsman and designer Jean Bérain the Elder (1637–1711).

The upper tier of the cabinet has double doors. Behind the outer door, with its openwork grille, is a glass door of similar design through which one can view the valuable collections stored within.

It is likely that the set of cabinets was dispersed after the fire at the Grey Castle in 1830. The individual pieces are currently in various museums and private collections. Nowadays, Brunswick cabinets are considered to be one of the most interesting ways of presenting Regency period collections.

MC

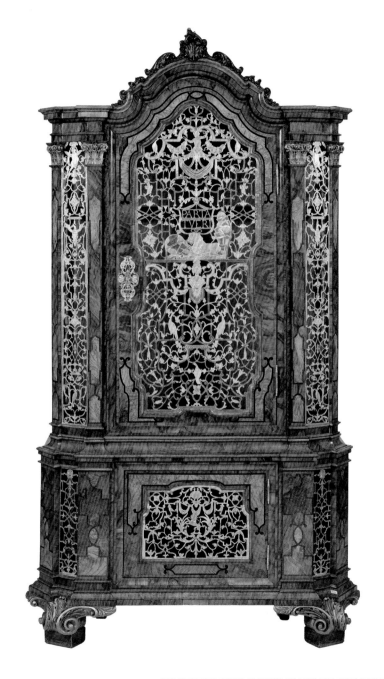

***Goblet,*** *c.* 1740
Saxony
Colourless glass, cut, engraved, h. 27 cm
Acquired in 1998
ZKW/4123

GOBLETS WITH ENGRAVED HERALDIC DECORATION relating to the kings of Poland from the Wettin dynasty, August II and August III – that is, a five-quarter shield with the coats of arms of Poland, Lithuania and Saxony under the royal crown – were commonly produced. The Order of the White Eagle and the Order of the Golden Fleece, of which both rulers were knights, were often placed under the coats of arms, but the Order of the Elephant seen here is a fairly rare occurrence. Exceptionally, both August II and August III were awarded this highest and oldest order of the Kingdom of Denmark when they were still young men who had never held office: the former received the Order of the Elephant in 1686, at the age of 16; the latter in 1709, at the age of 13.

The goblet in the Royal Castle collection was made for August III; its form is typical of Saxon glass made *c.* 1740. It consists of a round foot, a faceted baluster stem, a ball-like knop between two flat mereses and a conical flaring bowl set on top of them, its base cut into concave double leaves. The bowl is engraved with a cartouche bearing the aforementioned coats of arms supported by two eagles and flanked by panoplies. Visible below the cartouche is the Order of the Elephant in the form of a figurine of an elephant with a turret on its back and a cross on its side.

**AS**

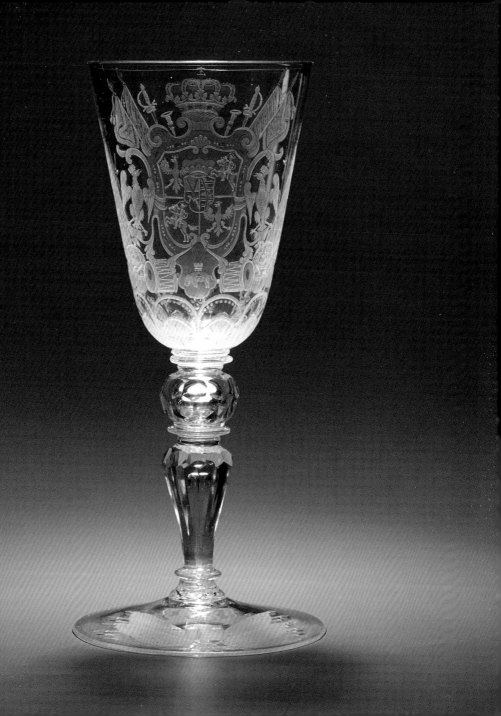

François Garnier (d. 1760)

## *Commode* en tombeau, *c.* 1745–55
Paris

Spruce, walnut, oak, rosewood, purple rosewood,
mahogany, gilt bronze, breche d'Alep marble, 92 × 147 × 66 cm
Acquired in 2019
ZKW/5679

A type of elaborate chest of drawers, developed in France during the Regency (the period between 1715 and 1723 when King Louis XV was a minor and the country was governed by Philippe d'Orléans), the commode *en tombeau* was used until the early 1780s with certain modifications. The term *en tombeau* refers to the fact that its shape reminded contemporaries of a sarcophagus. Commodes made during the minority of Louis XV were also referred to as *à la Régence*. The characteristic features of the style are: a prominently bulging middle part at the front and sides, four drawers in three tiers, short legs and a rich set of gilt bronze fittings.

The piece shown here was made during the middle period of the fashion for commodes *en tombeau*. This is evidenced by the softer profile, the higher legs and the large apron with wavy lines and floral inlay, which reappears on this type of furniture in the early 1840s. The monumental commode is embellished with high-quality bronzes: masks of Apollo and Boreas and female heads (espagnolettes); it is a stylistically uniform piece, characteristic of the furniture of the first quarter of the eighteenth century. It was undoubtedly designed and made to individual order.

The maker of the piece is François Garnier, whose signature is stamped in four places on the tabletop, beneath the marble slab. This *ébéniste* (the French word for cabinet-maker) was active in Paris from *c.* 1730 and had his studio on the Rue Saint-Antoine. Thanks to his growing reputation, he served as a sworn officer of the cabinet-makers' guild between 1742 and 1744. He created furniture characterised by good proportions and meticulous craftsmanship – in the Regency and Louis XV styles – using inlay or *vernis Martin* lacquer, imitating Chinese lacquer.

MC

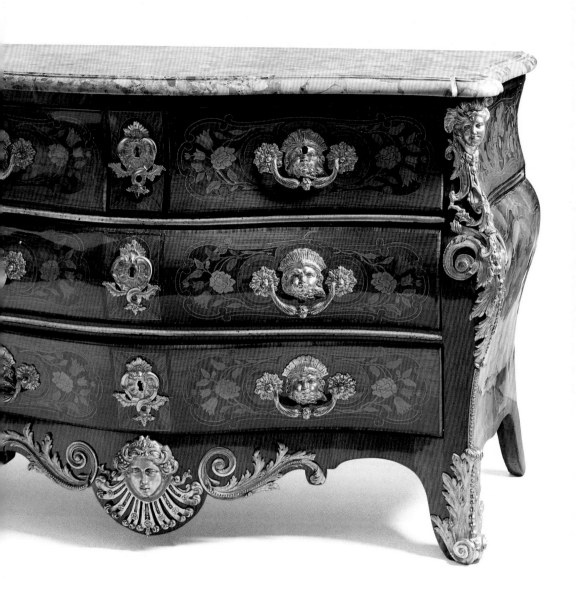

Jan Regulski (*c.* 1760–1807), intaglio
Jean Martin (active in Warsaw 1769–95), setting

## *Jewel with a Portrait of Stanisław August*, 1786
Warsaw

Ceylon sapphire, diamonds, gold, 6.5 × 3.3 cm
Donated by the Ciechanowiecki Collection Foundation in 2019
ZKW/5789

This bust-length sapphire portrait of Stanisław August (Stanislaus Augustus) shows the last king of Poland in classical style, with a naked torso, but with a Rococo hairstyle sporting lush curls. The intaglio signed with the initials *J.R.*, framed by a wreath of diamonds and topped with a diamond crown, was cut in transparent stone by Jan Regulski, a royal gem cutter and medal engraver. Regulski, a Polish nobleman, received his education in Italy. He was a collector and an expert on antiquity, and practised the art of gem cutting, which was particularly valued at the time. He worked primarily for Stanisław August, carving portraits of the king and members of his family, and providing copies of ancient gems for the royal collection. When the monarch lived in Grodno and in exile in St Petersburg after his abdication, Regulski continued to work for him. He also made at least three portraits of Catherine II (the Great) of Russia.

The intaglio was set by another royal artist – Jean Martin, a jeweller who came to the court of Stanisław August in 1769. He became the almost exclusive supplier of jewels – usually featuring a portrait or monogram of the monarch – as well as rings, snuff boxes and medallions, which the king would lavish on his family, subjects, diplomats and foreign guests. He also monopolised the production of Orders of the White Eagle and Orders of St Stanislaus, and created unique works such as a nautilus shell set in gold and decorated with gemstones, which is now in London's Victoria & Albert Museum.

This sapphire and diamond jewel worth 3,000 ducats – the work of two of the most important royal craftsmen – was intended as a special gift, behind which was a political calculation. It was most probably given to Count Alexander Bezborodko on 28 March 1787 in Kaniów on the Dnieper River, where Stanisław August had arrived to meet Catherine II of Russia. Bezborodko was a Russian dignitary who had a major influence on the fortunes of the Polish-Lithuanian Commonwealth at that time and during its subsequent years of decline. Perhaps the expensive gift helped the tsarina accede to one of the king's demands in the negotiations: to grant approval for a confederated Sejm (in other words, a parliament whose decisions would be made by a majority of votes cast and would thus be immune to the infamous noble privilege of liberum veto). The confederated Sejm went down in history as the Four-Year Sejm; its crowning achievement was the adoption of the Constitution of 3 May 1791.

**DS-P**

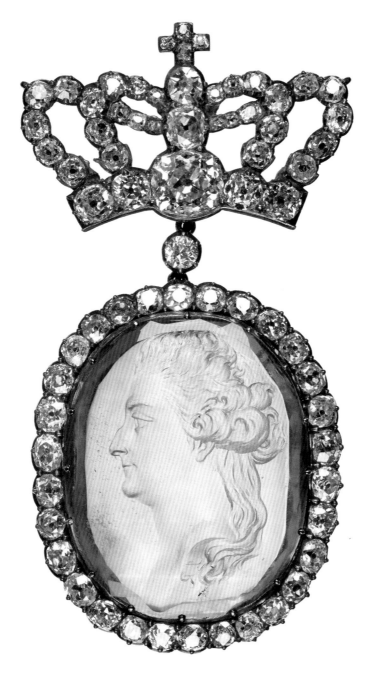

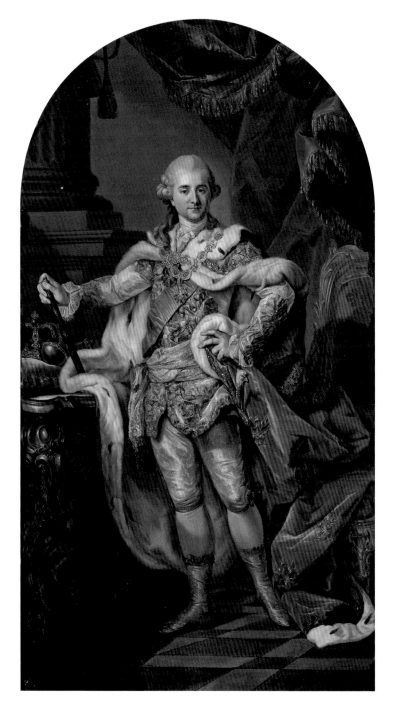

Marcello Bacciarelli (1731–1818)

## Stanisław August in Coronation Robes, 1767–71

Oil on canvas, 265 × 134.5 cm

From the former collection of Stanisław August

ZKW/2729/ab

Stanisław Poniatowski assumed the throne in 1764. He ruled until 1795, when the third and last Partition of Poland took place. The last Polish king was very much an Enlightenment monarch. He was well educated, and during his reign, on 3 May 1791, the first modern written constitution in Europe was passed. Stanisław August became known as a patron of culture, art and artists, as well as an avid collector. This is evidenced by the 2,500 paintings, not to mention the many sculptures, engravings and miniatures, he collected. In addition, the court of Stanisław August was home to a painting school (the so-called *Malarnia*), where artists were trained under the supervision of the court painter and artistic adviser to the king, Marcello Bacciarelli, who is the author of the portrait shown here.

This ceremonial, full-length coronation portrait, created in the years 1767–71, acquired the highest status among official images of the monarch. As such, it was copied many times during the king's reign with the purpose of being presented as a gift. Approximately 40 replicas and studio copies are known to exist, of which only a few are considered to be by Bacciarelli; the rest were painted by artists working in Bacciarelli's studio, some with the master's participation.

Bacciarelli composed the portrait according to the classical formula for this type of royal image, showing Stanisław August in ceremonial attire. The king is depicted with the insignia of power, next to a throne, with a column and a curtain in the background. From his neck hangs the cross of the Prussian Order of the Black Eagle, on his shoulders is a diamond chain of the Order of the White Eagle attached to a diamond cross, and over his left shoulder is a blue riband of that same Order. He is dressed in the robes that he wore during his coronation – after the anointing ceremony in the cathedral, that is: a silver-white coat decorated with gold braid, silver-white knee breeches and a red ermine-lined cloak embroidered with golden eagles. This outfit, referred to as the Spanish outfit, the outfit *à la van Dyck* or *à la Henri IV*, was inspired by the figure of Henry IV, who, as an example of a warrior-king, was widely venerated throughout Enlightenment Europe.

This portrait was painted especially for the Marble Room in the Royal Castle, where it is the culmination of a series of 22 portraits of Polish rulers, also by Bacciarelli.

**MK**

JAN JERZY PLERSCH (*c.* 1704–1774), sculptor and woodcarver
ANDRZEJ GRZYBOWSKI, 1987, designer of the arrangement of the gold braid

## *Throne of King Stanisław August*, 1764

Oak, red velvet, 157 × 87 × 66 cm
From the former Castle furnishings of 1764
ZKW/3385

THIS LATE-BAROQUE THRONE was made in Warsaw for King Stanisław August on the occasion of his coronation in 1764. The backrest is crowned with a cartouche bearing the coats of arms of the Commonwealth (the White Eagle of Poland and the Mounted Knight of Lithuania) and the Ciołek coat of arms used by the Poniatowski family. The cartouche is framed by the attributes of royal power – a sceptre and a sword; originally, it was probably adorned with a royal crown.

The coronation of Stanisław August took place on 25 November 1764 in the parish church (now cathedral) of St John in Warsaw. Three thrones were prepared for the ceremony. The first, which was used in the church, remained there until 1944, when it was probably destroyed by the Nazis. The second, described as a 'large chair under a throne', was intended for the Senators' Hall within the Royal Castle. During the coronation ceremony it was placed in the Old Town Square, where the cities of the Commonwealth paid homage to the newly elected monarch. The chair remained at the Castle until the king's abdication in 1795; it was sold by the former monarch a year later. The third throne chair was designed for the Audience Chamber, where the future monarch was ceremonially dressed before his coronation. This particular piece, which has fortunately been preserved in the Castle collection, is the oldest surviving throne of Poland's monarchs. A fragment of its backrest is depicted in Marcello Bacciarelli's portrait of *Stanisław August in Coronation Robes, c.* 1768. The throne was probably made by the outstanding sculptor and woodcarver Jan Jerzy Plersch, who worked at the Castle from 1762 to 1764.

During the Second World War, the piece was hidden in Warsaw's National Museum, from where it returned to the Castle in 1989 to be exhibited in the Senators' Hall.

MC

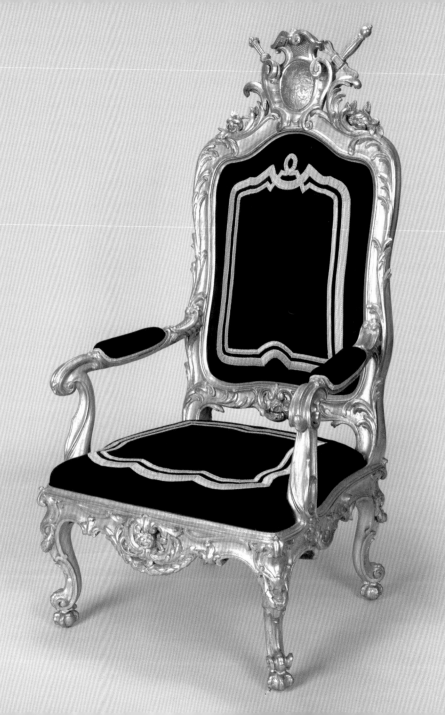

Efraim Schröger (1727–1784), design (?)
Joachim Friedrich Jacobson I (active in
Warsaw from before 1760 to before 1776), pommel

## Ceremonial Sword of Stanisław August, before 25 November 1764

Gold, silver, enamel, steel, velvet, 92.5 × 15.5 × 4.5 cm

ZKW/1251/ab

This ceremonial sword of extraordinary artistic value was commissioned by Stanisław August in 1764, most probably as an insignia of the Grand Master of the Order of the White Eagle. Later it also served as an insignia of the Order of St Stanislaus, used in the investiture ceremony of Knights of the Order which was held every year on the king's name day.

The pommel in the form of an eagle's head is a reference to an older tradition – sabres with such pommels were used in the coronation ceremonies of Jan III Sobieski (John III Sobieski) and August II (Augustus II). Completing the decoration of the sword are miniature plaques bearing images of the Virgin Mary and St Stanislaus as well as a cartouche containing the Commonwealth and the Ciołek coats of arms, the latter being used by the Poniatowski family. The following inscription appears on the pommel: *Stanislaus Augustus Rex Dedit ANNO 1764.*

It may be assumed that the designer of the sword was Efraim Schröger, a renowned architect who also designed the monarch's first seal and the console tables for the episcopal insignia displayed in the Castle on the day of the coronation. He probably also designed the throne made at that time and possibly the chain of the Order of the White

Eagle. The pommel is archivally confirmed as the work of Joachim Friedrich Jacobson I. It is possible that the hilt of the sword was made in Warsaw by the *François Ponce et fils* company – jewellers previously associated with the court of August III, who, along with two other contractors, made the first crosses of the Order of St Stanislaus, which was established in 1765.

The sword, mentioned many times in royal inventories, was also documented in drawings – it is among the regalia in a preparatory drawing for the coronation portrait of Stanisław August, which recorded elements of the royal attire (1764) – and in paintings: it is visible in a portrait by Joseph Christoph Werner, resting on a table next to the royal orb and grand duke's mitre, and in a coronation portrait by Marcello Bacciarelli, in which the king has it by his side.

The king took the sword first to Grodno and then, after his abdication, to St Petersburg. Following the death of Stanisław August, the sword was given over to the Kremlin Armoury (Оружейная палата) on the orders of Tsar Paul I of Russia. Recovered in 1928 under the Treaty of Riga, it was exhibited in the Throne Room of the Royal Castle in Warsaw until the outbreak of the Second World War. Together with the President's Chancellery it was evacuated to Romania, then to France, and finally to Canada, from where it was returned in 1959. After the reconstruction of the Castle, the sword was returned to its rightful place. It is exhibited alongside the preserved insignia of the last king of Poland: the chain of the Order of the White Eagle and a gold and aquamarine sceptre dating from 1792.

DS-P

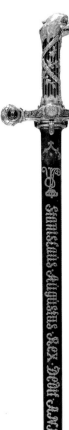

JOHANN MELCHIOR DINGLINGER (1664–1731)

### *Medal of the Order of the White Eagle*, *c.* 1704 (?)

Gold, enamel, polished cast, 3.8 × 2.6 cm

From the Nieśwież Castle treasury of the Radziwiłł family, acquired in 1990

ZKW.N.6861

THE ORDER OF THE WHITE EAGLE is the highest Polish honour. Its origins hark back to a meeting between August II and Tsar Peter I of Russia in November 1705 in Tykocin. Although a few distinctions had been awarded previously, it was then that the Order was bestowed for the first time. News of its establishment quickly spread.

The appearance of the first crosses of the Order remains a mystery to some extent, as only drawings of them have survived. The medals of the Order of the White Eagle are the oldest existing decorations of that Order and were probably meant as a replacement for crosses. Of the seven extant pieces, three are kept among the Saxon treasures of the Green Vault (Grünes Gewölbe) in Dresden, one is in the Museum of Medallic Art in Wrocław, and the remaining three are in the Royal Castle collection in Warsaw.

The Warsaw medals once belonged to the Radziwiłł family, and it is possible that Prince Karol Stanisław, the *ordynat* (entailer) of the estates in Nieśwież and Ołyka, was decorated with one of them. The medals shared the fate of the Nieśwież treasury, which was seized by the Russians during the Napoleonic wars. They were recovered in 1905 by Princess Marie de Castellane Radziwiłł, to whom Tsar Nicholas II returned part of the collection taken a century earlier.

**MZ**

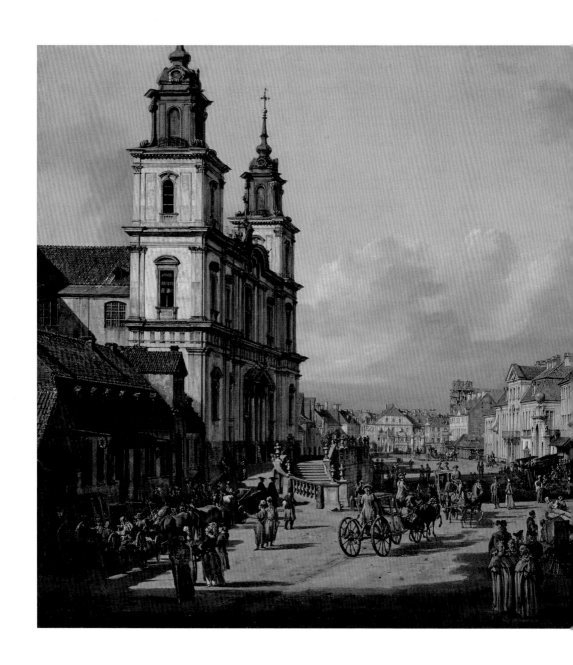

BERNARDO BELLOTTO (1722–1780)

## Church of the Holy Cross, 1778

Oil on canvas, 84.5 × 107.5 cm

From the former collection of Stanisław August

ZKW/446

THE CHURCH OF THE HOLY CROSS was built on Krakowskie Przedmieście in Warsaw near the Kazimierzowski Palace, a private residence of Polish monarchs from the Vasa dynasty. Krakowskie Przedmieście has for centuries been part of an important transport route connecting Warsaw with cities to the south, particularly Kraków (hence the name of the street). Many important buildings were erected along it, including churches belonging to the Bernardine, Carmelite and Visitandine orders and palaces of the most distinguished aristocratic families, notably the Radziwiłłs and Potockis.

In the painting, the street is depicted from the spot where a monument to Nicolaus Copernicus, the Polish astronomer, stands today. The lofty towers of the Church of the Holy Cross, the facades of the townhouses and the entrance gate of the Kazimierzowski Palace are bathed in afternoon sunlight. Pedestrians and carriages throng the street.

Bellotto's famous *vedute* – a series of views of Warsaw commissioned by King Stanisław August – would not have been complete without an image of the church shown here. The scene of important historical events and the burial place of several prominent figures, the Church of the Holy Cross was where part of Stanisław August's coronation ceremony took place and where each year the king would award the Order of St Stanislaus, a distinction he himself had established. At the king's request, the *Church of the Holy Cross*, together with other *vedute*, was hung in the Royal Castle in the room preceding the Throne Room; its interior was recreated during the rebuilding of the Castle after the Second World War and the salvaged series of paintings was hung there. Since then, the room has been known as the Canaletto Room – Bellotto was dubbed 'Canaletto' after his famous uncle, likewise a *vedutista*.

**AJ**

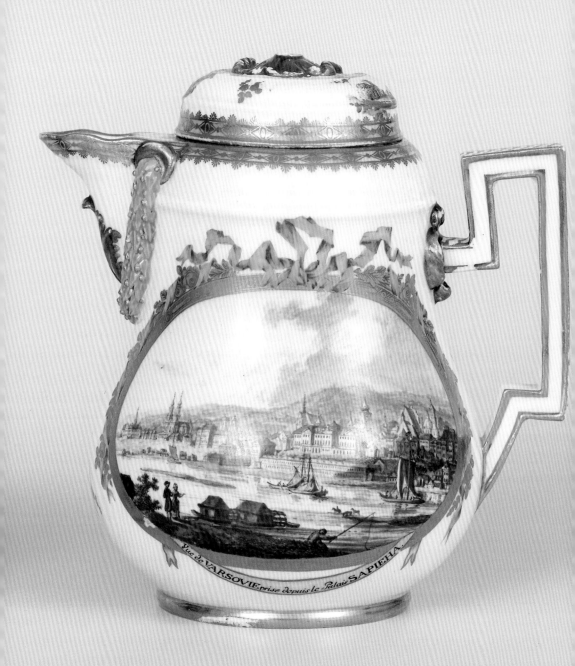

Vue de VARSOVIE prise depuis le Palais SAPIEHA.

## The Royal Porcelain Manufactory in Meissen

### Coffee Pot from a tête-à-tête Breakfast Service with Views of Warsaw by Bellotto (aka Canaletto), 1780–90

Porcelain, glaze painted, gilt, 13.5 × 13 cm

Acquired in 2019

ZKW/5678/a,b

THIS COFFEE POT was part of a *tête-à-tête* breakfast service adorned with views of Warsaw based on Bellotto's *vedute*. The service probably belonged to King Stanisław August and was described in the royal inventory as: 'Un dejeneur [*sic*] de porcelaine de Saxe avec des vües de Varsovie peint ser [sic] chaque piece'. Other pieces from the set have also survived: the teapot (in the Museum of Warsaw collection) and the tray (in the collection of the Landesmuseum in Stuttgart). Around the belly of the coffee pot are two polychrome paintings: a *View of Warsaw from the Praga District*, signed *Vue de Varsovie prise depuis le Palais Sapieha* and a *View of the Ostrogski Palace*, signed *Vue de Varsovie jusqes au [sic] Chateau*.

The form of the individual pieces of the service suggests a late eighteenth-century provenance (*c.* 1780–90). The coffee pot is signed in underglaze blue with the Meissen manufactory mark from the Marcolini period (two crossed swords with an asterisk beneath the crosspieces). Additionally, imprinted on the base, also in underglaze blue, is the number '28' and two dots.

From the 1730s, painters working at the Meissen manufactory used graphic works by various artists (now kept in the manufactory's archive) as well as *vedute* to decorate their porcelain. These included panoramas of Dresden and views of Saxon castles modelled on the work of Bellotto. This decoration was mainly applied to coffee and tea sets as well as to snuff boxes.

**AS**

Bernardo Bellotto (1722–1780)

## *View of the Capitol with the Church of Santa Maria in Aracoeli*, 1768

Oil on canvas, 77 × 106.5 cm

From the former collection of Stanisław August, acquired in 2018

ZKW/5613/ab

The Capitol (Capitolium) is one of the seven hills of Rome. In antiquity, numerous temples arose here, including that of Jupiter – the king of all the gods. During the Middle Ages, the seat of Rome's municipal government and the Church of Santa Maria in Aracoeli were erected here, along with the spectacular staircase (*cordonata*) leading up to the church.

The *View of the Capitol* was originally part of a series of views of Rome commissioned from Bellotto by King Stanisław August. Displaying such a series of works in one's home in the late eighteenth century was considered an indicator of good taste and familiarity with the world of culture. Interestingly, Bellotto executed the painting in Warsaw, basing it on a graphic print by Giovanni Battista Piranesi, the famous Italian graphic artist and architect. He very accurately reproduced the composition of Piranesi's print and the architectural detail, adding figures and a view of drying laundry. He also included a list of buildings in the lower-hand right corner, which he then numbered.

The series of views of Rome, originally intended for the Ujazdowski Castle, was finally hung in the Royal Castle in Warsaw. Over time, as the decoration of royal apartments changed, the views of Rome were replaced by views of Warsaw, and the Roman series was dispersed.

Fortunately, the *View of the Capitol* finally returned to its place of origin after a 220-year hiatus. For the Royal Castle, which was robbed of its collection during the Second World War and then destroyed by the Nazis, the return of such a valuable work was an extremely important event.

AJ

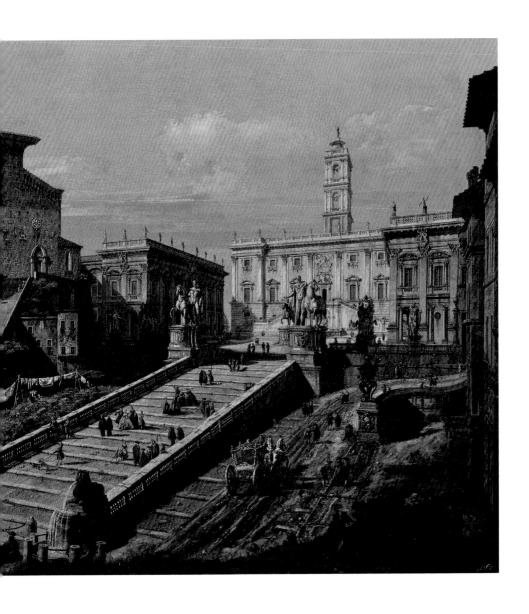

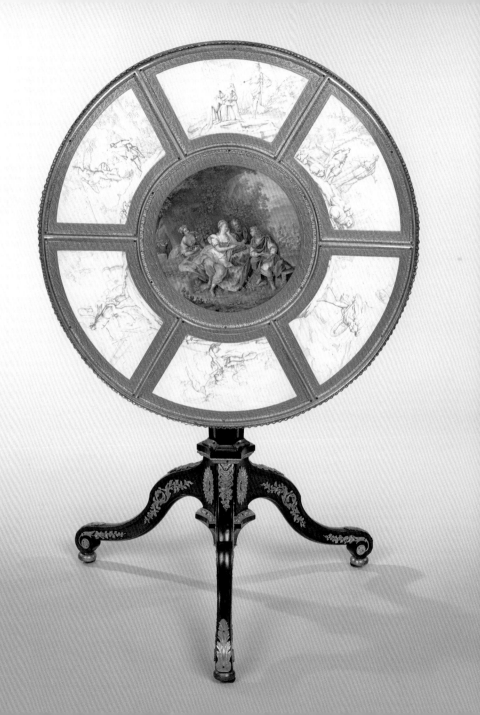

MARTIN CARLIN (*c.* 1730–1785), cabinet-maker
CHARLES-NICOLAS DODIN (1734–1803), porcelain painter

## *A Guéridon Table with Porcelain Top*, 1777
Paris and Sèvres

Oak, mahogany, gilt bronze, porcelain plaques, 85 × 81 cm
A gift from the Comte d'Artois to Stanisław August, c. 1780
ZKW/1246

THIS SMALL ROUND TABLE with a raised top is adorned with seven painted porcelain plaques depicting the story of Telemachus from François Fénelon's novel, *Les Aventures de Télémaque*, written in 1699. The polychrome image in the central plaque, based on an engraving by J.F. Beauvarlet from 1773, depicts Telemachus, Mentor and the nymph Calypso. The other six plaques are painted in grisaille.

The table is the work of two eminent Parisian artists: Martin Carlin – an *ébéniste* (cabinet-maker) of German origin, a master from 1766, specialising in furniture decorated with porcelain plaques and lacquer panels, and Charles-Nicolas Dodin – a porcelain painter and gilder, who collaborated with the manufactory in Sèvres.

The table is a unique piece. Made in *c.* 1777 and purchased in 1780 by the Comte d'Artois, the brother of the king of France, it was sent to Poland as a gift for Countess Elżbieta Grabowska, the morganatic wife of Stanisław August. It is possible that it was intended as a gift for the monarch himself, as France and the Commonwealth did not maintain diplomatic relations at the time.

It was briefly exhibited at a villa known as the White House in the Royal Łazienki Park in Warsaw, before finally ending up in the Royal Castle's Conference Room.

Attempts have been made to interpret the composition of the tabletop and to link the scenes depicted on it with the interior design of the Conference Room, to which guests would be invited after their audience with the monarch in the Throne Room. The didactic tale about the adventures of Telemachus, containing a plethora of often utopian Enlightenment ideas about power and the principles of statecraft, was meant to allow the king to present his own vision of government and the role of the ideal ruler within it.

MC

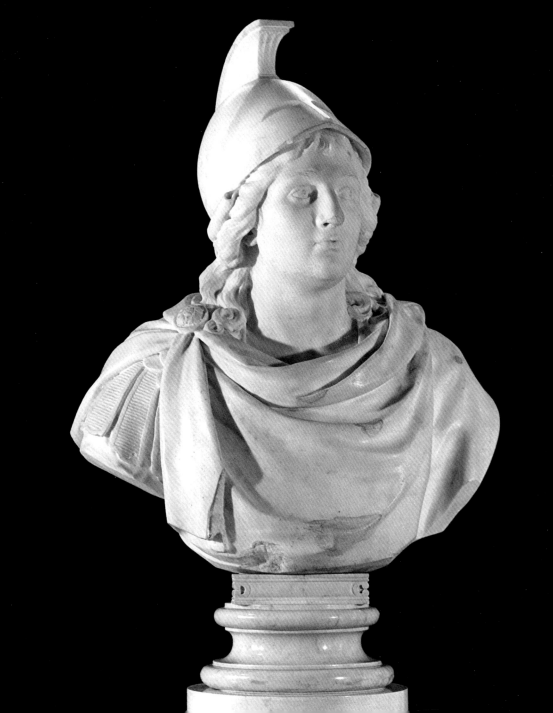

JEAN-ANTOINE HOUDON (1741–1828)

**Bust of Alexander the Great**, 1785

White marble; pedestal: blue marble, 98 × 72 × 34 cm

From the former collection of Stanisław August

ZKW/3424

DURING THE PARIS SALON of 1785, Jean-Antoine Houdon, a French sculptor at the height of his popularity, exhibited a completed model of a bust of Alexander the Great with the signature *Alexandre, pour le roi de Pologne*. This confirms that the bust was commissioned by Stanisław August, who was fascinated by Houdon's work, as were other contemporary rulers, notably Catherine II (the Great) of Russia and Frederick II (the Great) Hohenzollern of Prussia.

Brought to the Royal Castle in Warsaw in November 1784, on the king's orders the bust was installed in the Royal Library next to the bust of Octavian Augustus. When modelling the sculpture, Houdon was inspired by one of the most famous images of Alexander from antiquity – a Hellenistic bust made of porphyry, which, restored and supplemented at the behest of Louis XIV, was placed in the Cabinet du Conseil in the Palace of Versailles.

Houdon managed to create a bust resembling the ancient depictions of young heroes. The only difference is the deeply carved pupils, a feature typical of Houdon's work, which allow us to identify precisely the direction of Alexander's gaze.

**AB**

ROBERT OSMOND (*c.* 1711–1789), bronzeworker
FRANÇOIS VIGER (*c.* 1708–1784), clockmaker

## *Mantel Clock with Scene of the Abduction of Europa*, *c.* 1750–65

Brass, steel, copper, enamel, gilt bronze, 47.2 × 38 × 18 cm
Purchased at auction in 1994
ZKW/3632

THE CASE OF THIS Rococo mantel clock depicts the mythological scene of the Phoenician princess Europa caressing Zeus, who is transformed into a handsome bull. At the Paris Salon of 1747, François Boucher (1703–1788) exhibited his painting titled *The Rape of Europa*, which became the thematic prototype for models of clock cases produced over the next 20 years. The models were made by two renowned Parisian bronzeworkers: Jean-Joseph de Saint-Germain and Robert Osmond. The latter, who came from a prominent family of bronzeworkers and goldsmiths, probably produced his model in *c.* 1750.

The clock was acquired for the Castle collection at an auction in Warsaw in 1994 and is an example of the finest Parisian bronzeworking and clockmaking. The original Paris-type mechanism was made by François Viger (a master clockmaker from 1746), who put his signature on the enamel dial and on the back plate of the mechanism. The value of the piece is enhanced by Osmond's signature, since bronze clock cases made in the late eighteenth century were usually anonymous.

We know that Stanisław August owned a clock with figures depicting the abduction of Europa. It was recorded in the royal inventory of 1769, which contained a list of all items Kazimierz Czempiński acquired in Paris for the king after 1764. Although we cannot be certain from the brief description whether this was the clock with the Osmond case, it does seem very likely.

KN

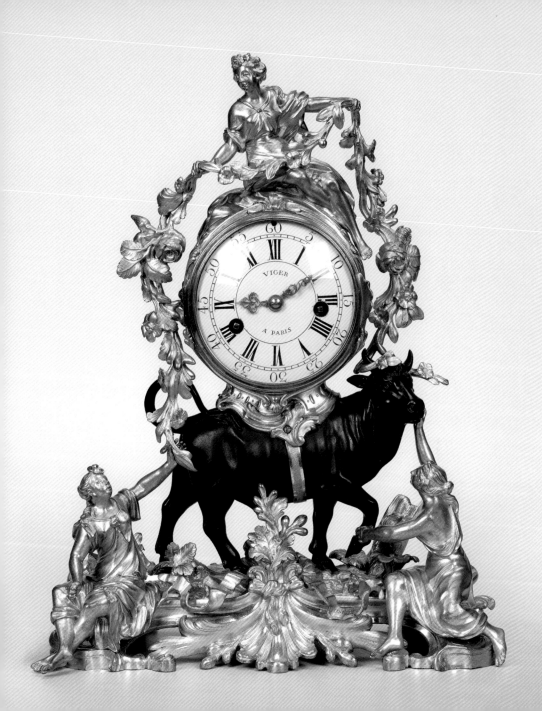

GIACOMO MONALDI (1730–1798)
FRANCISZEK GUGENMUS (1740–1820)

## *Chronos*, 1784–86

White marble, gilt bronze, gilt and silver-gilt metal, enamel, 254 cm
From the former Castle furnishings
ZKW/767

THE FIGURE OF CHRONOS is the principal element of a highly original clock (currently out of order) installed in the Knights' Hall. The clock mechanism, designed by Franciszek Gugenmus, is concealed within a globe on which there is a rotating ring with the hours marked on it, all supported on the back of an elderly man.

The time is indicated by the scythe held in Chronos's right hand, while the copper globe is covered with blue enamel and ornamented with 60 gilt stars. The depiction of a figure pointing to hours on the clock alludes to the popular symbolism of Chronos, the god of time, who at any given moment can extinguish human life with his scythe. In antiquity, however, Chronos (Khronos) was also identified with Saturn, ruler of Latium, which flourished thanks to his exceptionally wise and just rule. This symbolism of Chronos-Saturn was known to the designers of the statue and is visible in other elements of the décor in the Knights' Hall, the images of prominent people and the paintings illustrating glorious episodes from Polish history. Their purpose was to testify to Poland's past glory and to remind people that the reign of Stanisław August was similarly beneficial for the country.

The depiction of a naked old man with a long beard, holding a scythe, is a faithful rendition of images of the god of time popular in European art of the early modern period. The image of a man supporting a globe with stars was, in turn, borrowed from traditional representations of Atlas carrying the sky on his shoulders. Chronos-Atlas is therefore a symbol of the Polish monarch, who is forced to bear the burden of power. An important detail allowing Stanisław August to be identified with the god of time is the fact that the king was born under Capricorn, the sign ruled by Saturn.

**AB**

## *Dishes from the Sultan's Service*, 1776–77

Faience, muffle paint, gilt

5 plates: approx. 25 cm; tureen stand: 23 cm;

platter: 28.5 cm; 2 basket stands: approx. 21 × approx. 32 cm

Bequest of Tadeusz Wierzejski to the Royal Castle in 1974 (plate ZKW/110); on loan from the Ciechanowiecki

Foundation Collection (basket stands)

ZKW/110, ZKW/5758/1-4, ZKW/5779, ZKW–dep. FC/396: ZKW–dep. FC/409

The Royal Faience Manufactory at the Belvedere Palace (*c.* 1770–80), founded by King Stanisław August, produced faience crockery and decorative vases painted in the Chinoiserie style. It mainly fulfilled royal orders, among the most famous of which was a set of tableware sent as a gift by Stanisław August to Abdul Hamid I, the Turkish Sultan, from whom the set derives its name – the 'Sultan's Service'.

It consisted of 160 items: plates, round and oval platters, bowls, tureens and salt shakers. Each item bears a gold-painted inscription in Turkish by Stanisław August's court translator, Antoni Krutta, which may be translated as follows: *The King of Lechites sends these presents and gifts to the Ottoman Padishah to show his love and sincere goodwill.* The second set of tableware, without the dedicatory inscription, was kept by the king for himself: a total of 59 soup plates and 60 dinner plates were recorded in the Royal Castle inventory of 1795. Some test copies, without any inscription or gilding, also remain in Poland.

The Sultan's Service performed an official function, which is partly why it was elaborately decorated in the Japanese Imari style. The centre of the platter shown here is decorated with a vase of flowers, around which are four fields filled with red and gold chrysanthemums and a further four sporting fanciful patterns with stylised flowers,

butterflies and birds. Relief depictions of stylised lizards can also be seen on the rims of the platters and basket stands. The painter copied the pattern from Far Eastern porcelain (*c.* 1720–30) either directly from an original work or from a replica on Meissen porcelain.

Today, except for 52 items in the Topkapı Palace collection in Istanbul (which have survived from the 160 recorded in that palace's inventory of 1777), elements of the Sultan's Service are scattered around the world in various collections. The second largest collection in the world, and the largest in Poland, is the set of 12 items kept in the Royal Castle in Warsaw.

**AS**

PHILIPPE CAFFIERI (1714–1774)
VICTOR LOUIS (1731–1800), designer

### *Athénienne candelabra*, 1767
Paris

Gilt bronze, 96 cm

From the former Castle furnishings

ZKW/2035/1-6

ACCORDING TO THE ARCHIVES, this set of six ornate candelabra-tripods was completed before 2 September 1768. They bear the engraved signature: *fait par Caffieri*, with dates ranging from 1766 to 1768, and one even has the precise address of the workshop: *rue Princesse Faubourg St Germain*. Such careful signing of the product is unusual in the case of bronzes. The inscriptions attest to the artist's high opinion of himself, but also suggest that he was vying for the king's attention in the hope of receiving new commissions.

The motif of the classical tripod is present in seventeenth- and eighteenth-century painting and appears in James Stuart's designs for Spencer House in London (1758) and Kedleston Hall in Derbyshire (1757–58). Also similar to Caffieri's candelabras were Robert Adam's candelabras visible in the 1758 designs for Syon House in London.

The common source for these designs was probably the study of ancient monuments that all the artists – Stuart, Adam, Louis and Caffieri – undertook during their travels to Italy. King Stanisław August was likewise fascinated by antiquity and amassed a large library on the subject; it is likely that the design of these classical tripods met with his full approval.

The design of the candelabra for Stanislaw August was commonly attributed to Victor Louis. However, in Caffieri's works we notice forms analogous to those used in the candelabra in the Royal Castle collection. This suggests that the Parisian bronzeworker's influence over the final design was greater than initially assumed.

**AS-D**

André Le Brun (1737–1811)

*Sculptural decoration of the Marble Room*, 1769–71

White marble, gilt bronze, 170 × 240 × 40 cm
From the former Castle furnishings

The magnificent cartouche bearing the coat of arms of the Commonwealth (the White Eagle of Poland and the Mounted Knight of Lithuania) and the Ciołek coat of arms used by the Poniatowski family was completed in 1771 along with the figures of Justice and Peace which flank it. Le Brun carved the figures in Genoese marble and was assisted in this task by two journeymen: Giacomo Monaldi and Franciszek Pinck.

The coat of arms and the figures placed above the mirror on the south wall were to complete the ideological programme of the Marble Room, rebuilt after 1769 according to a design by Jakub Fontana, which was to serve as a place of commemoration of Poland's rulers. While the painted portraits of monarchs by Marcello Bacciarelli underscored the continuity of royal power, the figures of Justice and Peace expressed the idea that, by drawing on the experience of his predecessors, Stanisław August could imbue his own reign with those virtues. Indeed, in subsequent years, this pair of virtues would reappear in various decorations associated with the reign of Stanisław August. In making the figures for the Marble Room, Le Brun relied on the traditional iconography of the virtues, depicting Justice with a sword and scale, and Peace holding a palm branch with a laurel wreath on her head.

The figures of Justice and Peace, one of Le Brun's first works after his arrival in Poland from France, reveal the strong influence of French-inspired classicism. Both take the form of women with elegant hairstyles, dressed in costumes modelled on those of antiquity. Reference to the classical tradition in its French version can be seen in the way the robes are modelled, their surface being composed of small shallow folds.

**AB**

PIERRE GOUTHIÈRE (1732–1813), bronzes
JEAN-FRANÇOIS HERMAND (active *c.* 1764)

## *Mantelpiece Set*, 1764

Artificial porphyry, gilt bronze, 45 × 25 cm; 26 × 20 cm
From the former Castle furnishings
ZKW/2036; ZKW/2037/1-2

IN JULY 1764, just before the royal election and confident of success, Stanisław Poniatowski (elected as king of Poland on 7 September of that year) sent the merchant Kazimierz Czempiński to Paris to purchase decorations for the Royal Castle. Instructed to avoid objects designed in the by then unfashionable Rococo style, Czempiński headed to the workshop of the silversmith and bronzeworker François-Thomas Germain, a supplier to the aristocratic and royal courts of Europe. There Czempiński was able to choose items in the latest fashion – the *goût grec* ('Greek taste'). Among his acquisitions were three vessels made of artificial stone and finished in gilt bronze – a tall and slender vase decorated with a mask of Apollo and two incense burners.

Although the pieces were purchased as the work of Germain, in reality there were two other craftsmen working under the name of the famous Parisian artist. Following Germain's bankruptcy they wrote letters to the Polish king in which they revealed themselves to be the actual creators of the works and offered their services to the monarch. The two men concerned were Jean-François Hermand, later one of the best Parisian stucco-workers, who advertised himself as the inventor of a compound that could imitate stone and even dedicated his technological discovery to the king, and Pierre Gouthière, who was responsible for chasing and gilding the bronzes. In his rather brazen letter, Gouthière referred to Germain as a talentless bankrupt.

The pieces chosen by Czempiński originated from a series of vases made of stone or imitation stone, mounted in gilt bronze, which Germain advertised in the French press as late as 1766.

Preserved in the Neues Palais in Potsdam is a set of vases purchased in 1767 for Frederick II that are similar to the ones in the Royal Castle collection. In addition, two vases adorned with a mask of Apollo are preserved in the Ashmolean Museum in Oxford, while one incense burner belongs to a private collection. It is, however, only the Warsaw set that was carved and gilded by Pierre Gouthière and is the oldest known work of this excellent artist.

**AS-D**

André Le Brun (1737–1811)

*Bust of Stefan Czarniecki*, 1783 (model 1770–82)
Bronze, patinated cast; pedestal: black marble, 67 × 64 × 40 cm
From the former Castle furnishings
ZKW/3379

When designing, in collaboration with Adam Naruszewicz, the decor of the Knights' Hall dedicated to eminent Poles and important events in Polish history, King Stanisław August decided to pay tribute to four people in particular. The Hetmans (military commanders) Stefan Czarniecki, Stanisław Jabłonowski, Paweł Jan Sapieha and Jan Zamoyski are commemorated in portrait busts which are displayed in the corners of the hall against a background of panoplies and coats of arms. The shoulders of the four men are covered by cloaks falling in deep folds and tied with decorative cord. This aspect of the sculptures, most probably Le Brun's idea, recalls the composition of many official portraits made in French court circles in the early to mid-eighteenth century.

Czarniecki's bust in the Knights' Hall is one of several sculptures of him commissioned by Stanisław August. Le Brun also made a bronze half-bust which used to adorn the Castle's Audience Chamber as well as a marble half-bust which found its way into the collection of Prince Stanisław Poniatowski. The model for all three of the busts was in all likelihood a painting from Marcello Bacciarelli's workshop (now in the National Museum in Warsaw), which in turn repeats an anonymous eighteenth-century likeness in the Wilanów collection.

Both the painted portrait and the bust depict the Hetman with his hair shaved high up on the temples, a long beard, a wrinkled forehead and slightly pursed lips. The small scar visible on the right cheek may have been intended to recall the wound Czarniecki received in the Battle of Monasterzyska in 1653.

**AB**

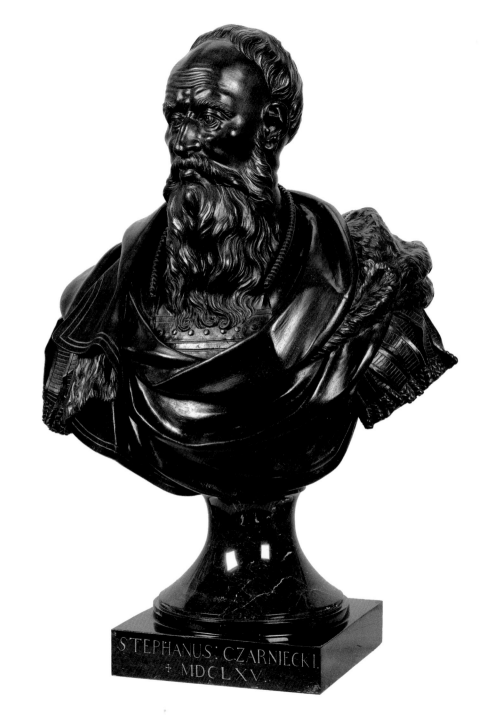

STEPHANUS: CZARNIECKI.
+ MDCLXV.

JAN MATEJKO (1838–1893)

## *Reytan. The Fall of Poland*, 1864–66

Oil on canvas, 282 × 487 cm
Acquired by Emperor Franz Joseph I in 1867
ZKW/1048/ab

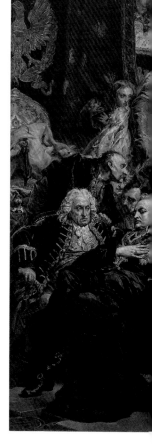

JAN MATEJKO is an extremely important artist for the Poles. During the Partition era (1795–1918), when Poland was wiped off the map of Europe, Matejko painted scenes from Polish history to remind his countrymen of their heritage and to strengthen patriotic feeling.

The work shown here depicts the dramatic events leading up to the fall of the Polish-Lithuanian Commonwealth. In the painting, parliamentary deputies are about to ratify the First Partition of Poland, under which parts of Polish territory were annexed by three neighbouring states: Russia, Prussia and Austria. One of the deputies, Tadeusz Reytan, tries to prevent this act from taking place. He is shown lying in the doorway of the Chamber of Deputies at the Royal Castle, exposing his chest in a defiant gesture to signify that he would sooner die than give his consent to the treaty.

The Partition of Poland could not be stopped, however. Reytan, devastated by the events in the Chamber, took his own life. Yet his attitude and gesture, captured by Matejko, would become a symbol of determination and resolve.

The First Partition and the two subsequent ones were caused by Poland's political weakness and its inability to maintain and continue the reforms introduced by the 3 May Constitution of 1791 (the first modern written constitution in Europe and the second in the world after the United States).

In *Reytan. The Fall of Poland*, as in his other paintings on historical themes, Matejko presented events in a concise and symbolic manner. He juxtaposed historical figures who did not meet at the time, but whose actions had a major impact on the course of events. He also gave the figures symbolic poses and gestures. King Stanisław August, for instance, shown standing on the left, has just risen from his throne and is looking at an open pocket watch.

**AJ**

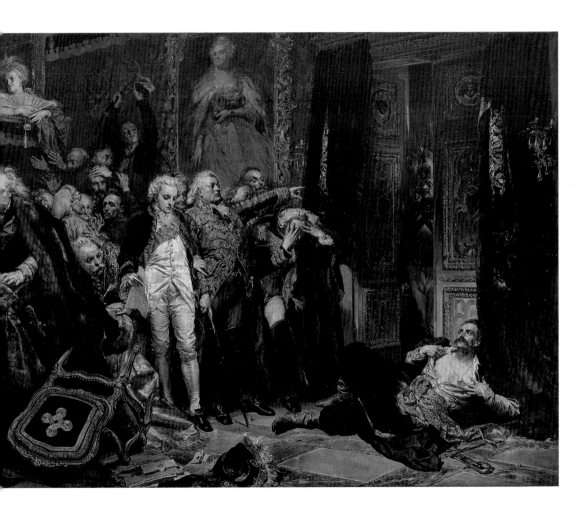

***Penny of Bolesław I the Brave with the inscription***
**Princes Polonie**, first decade of 11th century
Poland

Silver, 1.6 cm
Acquired in 1986
ZKW.N.4628

THE BEST KNOWN, although not the oldest, coin of Bolesław I the Brave (992–1025) is a silver penny inscribed with the words *Princes Polonie*. The second of these words – *Polonie* – is the earliest extant reference to the name of Poland, while the origin of the first – *Princes* – can be traced back to the coinage of Benevento in Italy. The meaning of the inscription as a whole testifies to the high aspirations of Prince Bolesław, especially in the context of the Congress of Gniezno (1000), a few years after which the coin was struck.

For many years scholars have debated not just the inscription on the coin, but also the images. While it is almost certain that the origin of the equal-armed cross can be attributed to Anglo-Saxon crux-type pennies from the late tenth century, the question of what bird is depicted on the reverse side was the subject of much controversy. It was variously interpreted as a dove, a cockerel and, first and foremost, as an eagle – the precursor of Poland's coat of arms. The debate was settled, however, when the bird was proved to be a peacock – a Christian symbol, here possibly alluding to the martyrdom of St Adalbert.

We do not know who designed the dies for the *Princes Polonie* penny, but they may have been inspired by the Archbishops Radzim Gaudente, Bruno of Querfurt or Abbot Tuni. Nor do we know exactly how many of these coins were struck, but several thousand seems likely. Until recently, the prevailing view was that two pairs of slightly different dies were used to strike the *Princes Polonie* penny. Careful research has shown, however, that there was only one pair of dies, which were repaired at some point and thus slightly altered. Currently, around a hundred of these coins are known to still exist, some struck before and some after the dies were repaired.

**MZ**

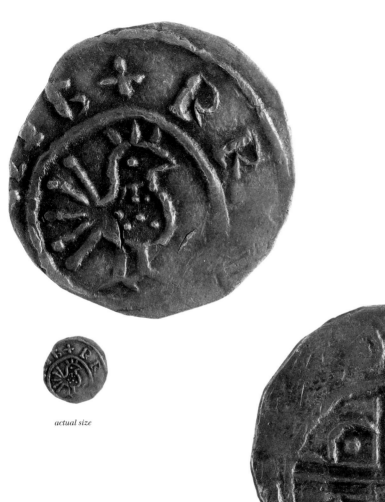

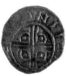

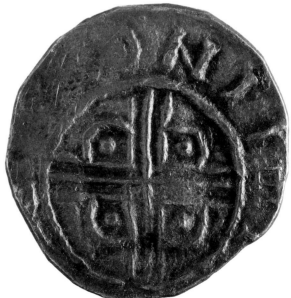

PENNY OF BOLESŁAW I THE BRAVE WITH THE INSCRIPTION PRINCES POLONIE | **79**

This edition © Scala Arts & Heritage Publishers Ltd, 2022
Text and photography © Royal Castle in Warsaw – Museum, 2022

First published in 2022 by
Scala Arts & Heritage Publishers Ltd
305 Access House, 141–157 Acre Lane
London, sw2 5ua
United Kingdom

www.scalapublishers.com

In association with the Royal Castle in Warsaw – Museum
www.zamek-krolewski.pl/en

isbn 978-1-78551-286-5 (Scala)
isbn 978-83-7022-302-1 (Royal Castle in Warsaw – Museum)

Translation from Polish: Jasper Tilbury in association with
First Edition Translations Ltd, Cambridge, UK
Editing: David Price in association with
First Edition Translations Ltd, Cambridge, UK
Co-ordination (Royal Castle in Warsaw – Museum):
Magdalena Białonowska, Tatiana Hardej
Project editor (Scala Arts & Heritage Publishers): Sandra Pisano
Designer: Matthew Wilson
Printed in Turkey

10 9 8 7 6 5 4 3 2 1

All rights reserved. No part of this book may be reproduced, stored
in a retrieval system or transmitted in any form or by any means
electronic, mechanical, photocopying, recording or otherwise,
without the written permission of the Royal Castle in Warsaw –
Museum and Scala Arts & Heritage Publishers Ltd.

Every effort has been made to acknowledge correct copyright of
images where applicable. Any errors or omissions are unintentional
and should be notified to the Publisher, who will arrange for
corrections to appear in any reprints.

Director's Choice® is a registered trademark of
Scala Arts & Heritage Publishers Ltd.

**Authors:**
Artur Badach (AB)
Maciej Choynowski (MC)
Alicja Jakubowska (AJ)
Magdalena Królikiewicz (MK)
Konrad Nawrocki (KN)
Katarzyna Połujan (KP)
Anna Saratowicz-Dudyńska (AS-D)
Danuta Szewczyk-Prokurat (DS-P)
Anna Szkurłat (AS)
Michał Zawadzki (MZ)
Marta Zdańkowska (MZd)

**Photographers:**
Artur Badach
Maciej Bronarski
Tatiana Hardej
Paweł Kobek
Małgorzata Niewiadomska
Zbigniew Panow
Andrzej Ring
Lech Sandzewicz
Michał Zawadzki

front cover:
Façade of the Royal Castle
in Warsaw, photo by
Z. Panow

back cover:
Rembrandt van Rijn, *The
Scholar at His Writing
Table*, 1641, Royal Castle
in Warsaw, photo by
L. Sandzewicz, A. Ring

frontispiece:
Bernardo Bellotto, *View
of Warsaw from the Praga
District*, 1770, Royal Castle
in Warsaw, photo by
L. Sandzewicz, A. Ring

cover flaps:
Marble Room, Royal Castle
in Warsaw, photo by
L. Sandzewicz, A. Ring

Prof. Wojciech Fałkowski,
photo by M. Niewiadomska,
A. Ring